IMAGES
of America

HISTORIC FIRES OF NEW YORK CITY

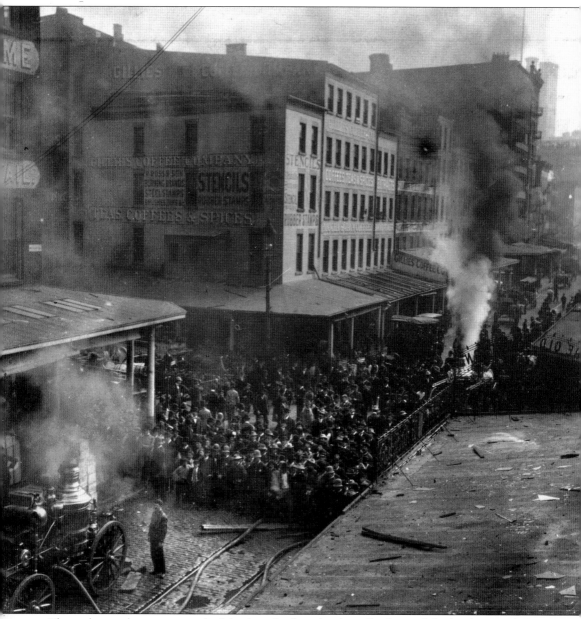

The authors welcome you to a look back at the fires that literally changed the landscape of New York City. Join us as we travel back in time to smoke-filled streets where the shouts of firemen, the clanging of bells, the wail of sirens, and the intense heat of fires long ago still burn in the pages of history.

IMAGES
of America

HISTORIC FIRES OF
NEW YORK CITY

Glenn P. Corbett and Donald J. Cannon

ARCADIA
PUBLISHING

Published by Arcadia Publishing
Charleston SC, Chicago IL, Portsmouth NH, San Francisco CA

Printed in the United States of America

Library of Congress Catalog Card Number: 2005925674

For all general information contact Arcadia Publishing at:
Telephone 843-853-2070
Fax 843-853-0044
E-mail sales@arcadiapublishing.com
For customer service and orders:
Toll-Free 1-888-313-2665

Visit us on the Internet at www.arcadiapublishing.com

*Dedicated to our families, Sharon Corbett, Delia Murphy,
and Peter Murphy Cannon, who have patiently dealt with us as
we entered and returned from our parallel historical time warp, as well
as to the memory of all those lost in the attacks of September 11, 2001.*

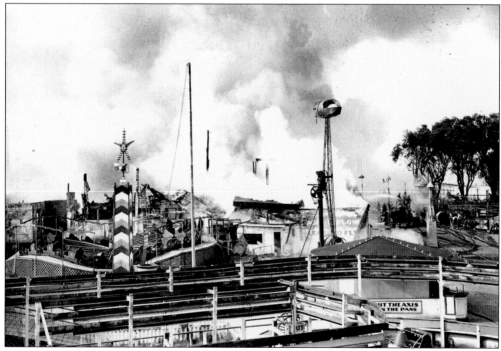

Pictured here is the Luna Park fire of 1944.

CONTENTS

ACKNOWLEDGMENTS

We wish to thank the many helpful people who provided assistance, images, and (most importantly) encouragement for this project. To the expert librarians of Fire Department of New York's (FDNY) Mand Library, Honorary Chief of Department Jack Lerch, and Lt. Daniel Maye, we owe a great debt of gratitude. To Deputy Commissioner Francis Gribbon and the wonderful FDNY Photo Unit, we give bountiful thanks. To Janet Kimmerly, the superb editor of *With New York Firefighters* (WNYF) magazine, we offer our sincerest appreciation.

To the gracious Wendy McDaris, curator, Firemen's Association of the State of New York (FASNY) American Museum of Firefighting in Hudson, New York, we extend our thanks to her and for her hospitality. To photographers Joe Pinto and David Handschuh, we are grateful for your superb firefighting photographs. To Kate Strassman, we thank you for your enthusiastic assistance with our graphics. To editor Bill Manning and managing editor Diane Feldman of *Fire Engineering* magazine, we express our heartfelt thanks for allowing us access to the *Fire Engineering* archives and for your friendship over many years. Finally, we want to thank the American people for supporting the Library of Congress from which some of the images were gathered.

INTRODUCTION

In planning this book, we committed ourselves to presenting a cross section of firefighting challenges from Dutch New Amsterdam to English New York, when it was just lower Manhattan, to the establishment of "the Greater City of New York" in 1898 and, ultimately, to the tragic events of September 11, 2001. The more we unearthed, the more we realized that we were just scratching the surface.

Our efforts grew out of shared interests. Glenn Corbett, a fire safety engineer, is coordinator of the Fire Science Program at John Jay College of Criminal Justice (CUNY), a technical editor with *Fire Engineering* magazine, and a suburban assistant fire chief. Don Cannon, Ph.D., a professor of history at Saint Peter's College, is particularly interested in FDNY, an honorary deputy chief of FDNY, a veteran of more than 40 years of volunteer fire and EMS service, editor of *Heritage of Flames: the Illustrated History of Early American Firefighting*, and was a contributor of several articles on fire and firefighting for the *Encyclopedia of New York City*. Don also teaches an online course at John Jay entitled Fire in New York.

As we wrote, we realized that some things we knew; that is, the past is prologue; the more things change the more they stay the same. But we also reinforced a number of other rather common sense truths: that the threat of fire is unrelenting; those who do the work, love to do the work; and last, that vigilance and integrity are humanity's best defense.

We are very excited about the explosion of Internet and computer technology, which places more and more information at our disposal every day. Our only regret is that so many images portraying very important moments in the city's past were inaccessible at time of publication. As more collections open up, they may provide material for another volume, including fires such as the Great Brooklyn Fire of 1848, the Staten Island conflagration of 1962, the Twenty-third Street collapse of 1966, the Queens Father's Day hardware store fire and Belle Harbor plane crash of 2001.

We hope you will find *Historic Fires of New York City* rewarding.

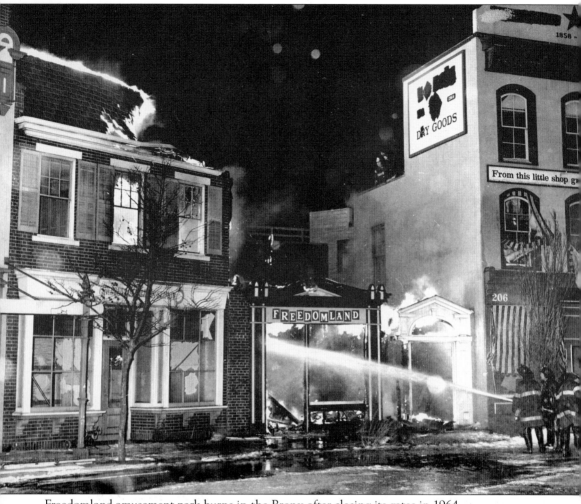

Freedomland amusement park burns in the Bronx after closing its gates in 1964.

One

1626–1865

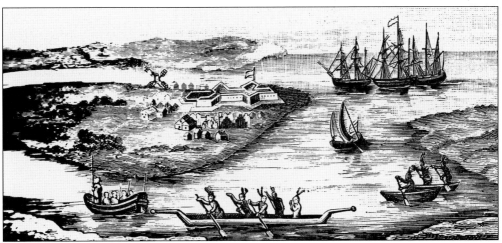

Founded in 1626, the first recorded fire in the area that became New York City occurred in 1628. By the 1650s, the population of New Amsterdam numbered about 1,000 people, clustered at the tip of Manhattan. Many early homes were built of stone, much of which had been brought in as ship ballast. In 1658, a night patrol was established to watch for fire. Patrolling the streets at night looking for fire, they were called the rattle watch or "the Prowlers." In the event of fire, they were required to awaken their fellow townsmen by shouting out and swinging their ratcheted noisemakers. Householders were then required by law to bring fire buckets to the scene of the incident and join a bucket brigade.

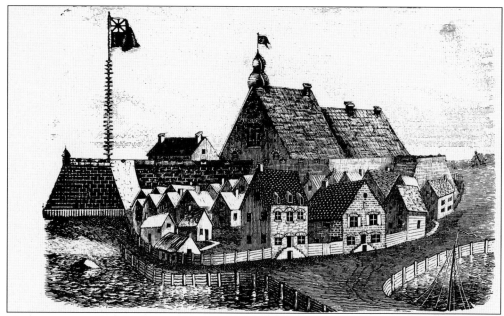

This is a portrayal of the home of Jacob Leisler, reputed to be the first brick building in New York. Such construction usually limited the extension of fire. However, the use of thatched roofs and wood chimneys were an invitation for disaster. Thus, as early as 1648, the Dutch employed fire wardens to enforce regulations prohibiting wooden chimneys, to inspect faulty chimneys, and to fine the owners of such buildings in violation.

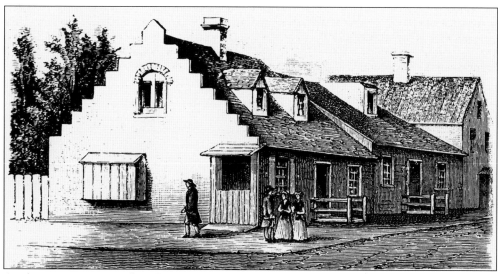

As the town grew, Dutch influence in architectural design remained strong. However, as the years went by, homes built of brick became more expensive. Thus, as wood gradually came into greater use, it created the potential for wider scale fires, a real problem for pickup teams of disorganized and terrified bucket-wielding burghers.

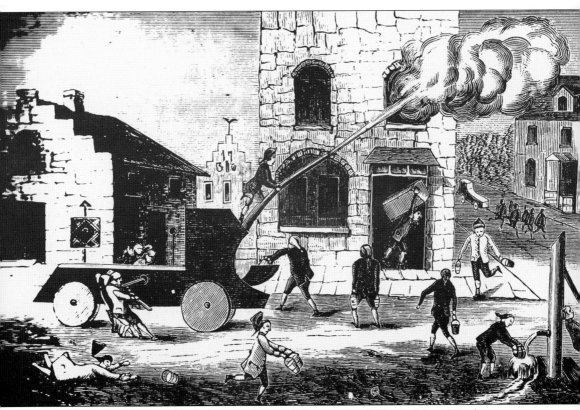

Something must have really shaken up the city fathers in the 1730s. In May 1731, the common council introduced a series of revolutionary changes in firefighting when it authorized the purchase of two up-to-date, London-built, Newsham hand-pumped fire engines. By the end of November 1731, when the apparatus arrived, it was estimated that New York had about 1,200 houses. Known simply as Engine 1 and Engine 2, they were housed in a shed near city hall. They were put to work right away, as a Boston paper noted in early January that "by the aid of the two fire engines, which came from London in the ship Beaver, a fire was extinguished after having burnt down the house and damaged the next."

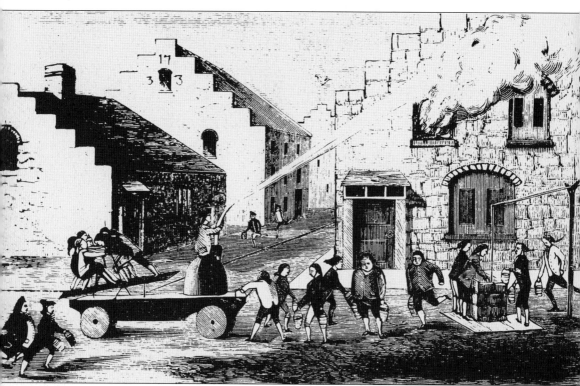

Every solution brings new problems. The new pieces of apparatus depended on 10–20 men to pump water supplied by citizens. And while each was less than three feet wide, they were heavy and awkward to pull to the scene of any fire. Thus, in 1737, the general assembly authorized the enlistment of 30 "strong, able, discreet [sic], honest, and sober men" who were expected to be "diligent industrious and vigilant." They were specifically required to manage and care for the fire apparatus and be ready for service "by night as well as by day." This first generation of volunteers served until the British occupation of the city during the Revolution effectively disintegrated their organization.

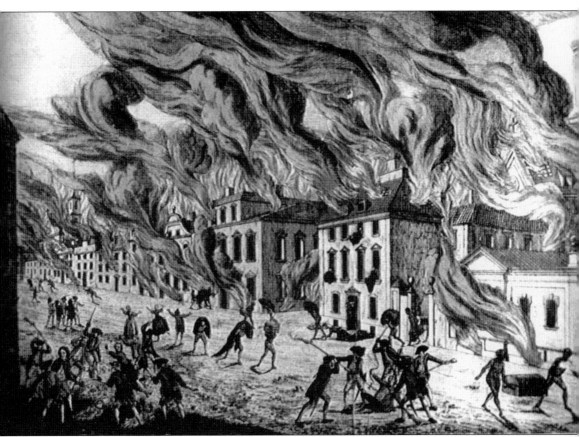

Set by arsonists supporting the Revolution, the Great Fire of 1776 was intended to deny the use of the port to British occupying forces. Originating in the Fighting Cocks Tavern southeast of the Battery and fanned by southerly winds, the flames swept northward to Barclay Street, halting just short of Kings (later Columbia) College. The fire destroyed almost a fourth of the city, between 600 and 1,000 buildings. A second fire caused by arson swept through the city in 1778.

One of the great landmarks of New York by the time of the American Revolution was Trinity Church, which was destroyed by fire in 1776. After English military forces occupied the city in August 1776, most of the inhabitants fled, leaving prewar civil government in ruins. With the collapse of the volunteer organization, fire protection was supplied primarily by naval personnel and by informal groups of civilians. Most of the church bells, which also served as fire alarms, had been taken by Washington's forces to be melted down for ammunition before they were forced to flee northward into the countryside after the Battle of Brooklyn Heights.

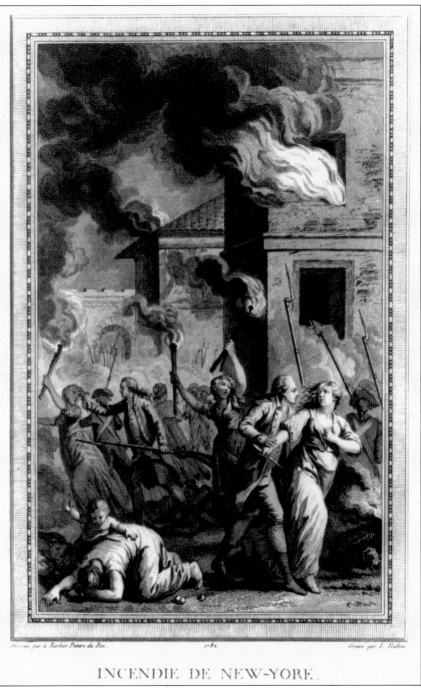

INCENDIE DE NEW-YORK.

This is believed to be a French print representing the fire of 1776, which was another disaster for those residents and merchants who had remained in the British-held fortress of Manhattan. By 1778, French interest in trying once again to defeat their traditional enemy, the English, was growing. A treaty of alliance between the Bourbon monarchy and the Continental Congress was signed that year. Thus, more attention was being paid to events in the rebellious colonies of North America.

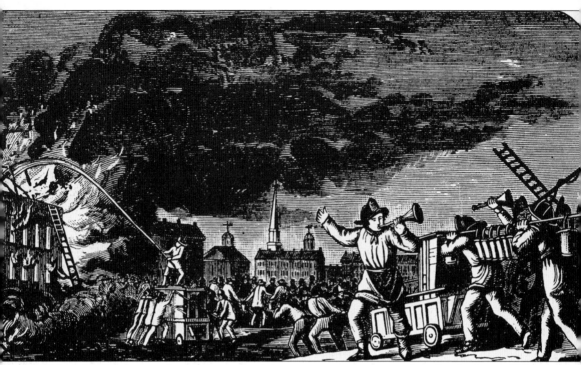

After the Revolution, the volunteer fire department was reconstituted under the laws of New York. This print portrays firemen at work in the early 19th century. Note that in comparison to earlier illustrations, the buildings are a bit taller, ground ladders are in position, and organized bucket brigades are at work with what seems to be one person directing the operation. Some things never changed, for one can see the occupants carrying out their bedding and possessions while the fire roars above and behind them. The volunteer organization survived until 1865.

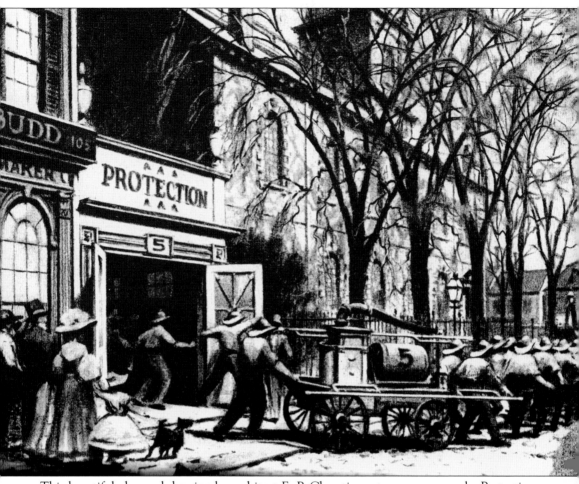

This beautiful charcoal drawing by architect E. P. Chrystie portrays a response by Protection Engine 5 (the "Honey Bee" Company) from their quarters on Fulton Street, just west of William Street in the early 1830s. Similar illustrations portraying the early days of the volunteer era with a grace and intensity never equaled may be found in Kenneth Dunshee's classic work, *As You Pass By.*

Walking Tour of
The Great Fire of 1835

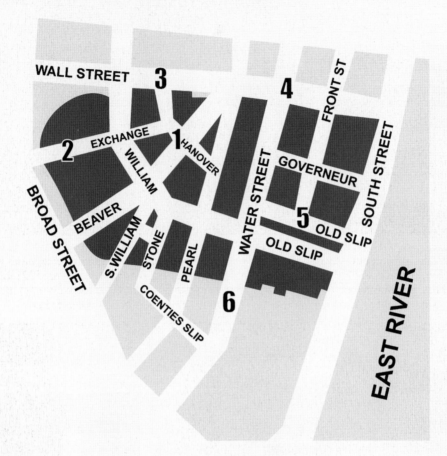

1) Start of fire
2) Site of Old Dutch Reformed Church
3) Site of Merchants' Exchange
4) Site of Tontine Coffee House
5) Site of saltpeter storage
6) Site of Coenties Slip warehouse

Note: the shaded area indicates the extent of the burnt district.

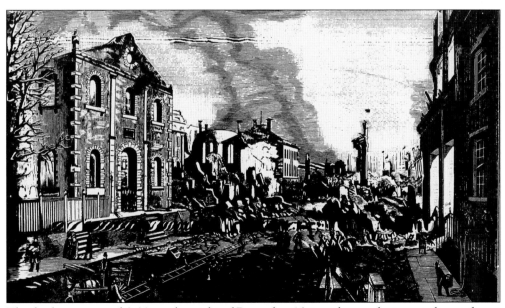

The great fire of December 16–17, 1835, devoured more than 674 buildings in New York's old mercantile and shipping district. Over 60 New York units were augmented by companies from Brooklyn, Newark, and Philadelphia. The loss in today's dollars is estimated at over $500 million. To begin the walking tour, one must first head to Hanover Street and Exchange Place (identified as No. 1 on the map), shown in the center of this view from Wall and William Streets.

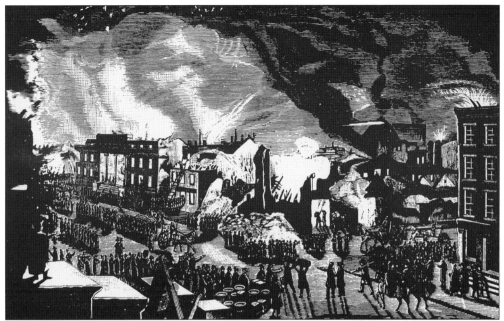

The fire began around 8:00 on the night of December 16, in a dry goods store at the southwest corner of this intersection. Firefighters had to deal with freezing temperatures and gale force winds. In an ineffective effort to save the goods of the many storehouses in this area, individuals removed stock into Hanover Square and into the Reformed Dutch Church (shown destroyed on the left side), which is identified as No. 2 on the tour.

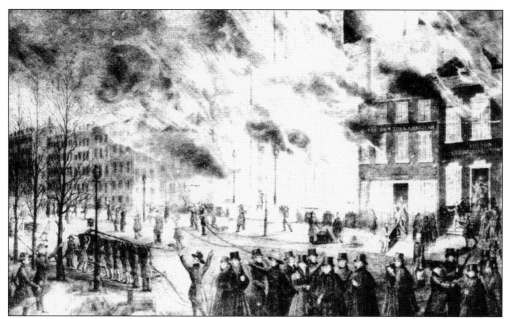

The next stop is No. 3 on the map, the Merchant's Exchange, which is the location of one of the most imposing edifices in the city. The Stock Exchange was located on the southwest corner of Wall and Hanover Streets. It withstood the flames for quite a while, but succumbed around 2:00 in the morning on December 17. Inside the ornate Westchester-marbled building was a statue of Alexander Hamilton, which was destroyed with the building.

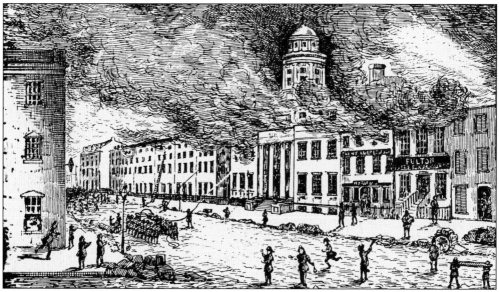

Following the fire down Wall Street, the next stop is identified as No. 4. With the fire moving from the Merchant's Exchange toward the East River (as seen in this view), great concern arose when the cornice of the Tontine Coffee House caught fire. Located near here on the northwest corner of Wall and Water Streets, it was a historic building used to transact business. Firefighters were successful in containing the fire, keeping it from spreading north and consuming the rest of the city.

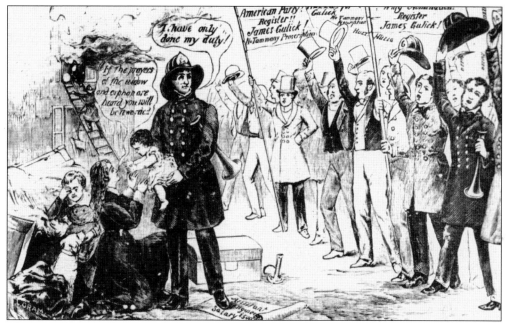

The area identified as No. 5 on the map is where exploding saltpeter warehouses became involved in the fire. Desperately, Chief Engineer James Gulick ordered explosives to be used to blow up other structures in an attempt to arrest the progress of the fire. Although loved by firefighters, and considered a hero of the Great Fire, Gulick was removed by the common council the following year. Mounting a comeback by running for the position of city register, he was supported by cartoons similar to the one above, published in local papers by his supporters.

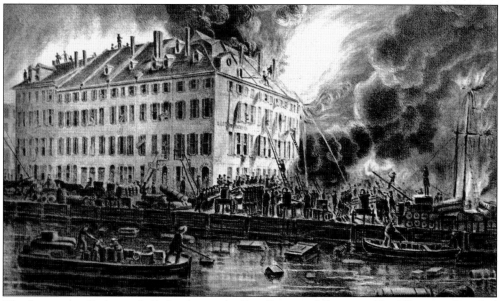

The fire eventually burned all the way to the East River and Coenties Slip. The area identified as No. 6 on the map is the approximate location of the large shipping warehouses shown in this image. It was here that the fire eventually stopped on December 17. The fire ruined 13 acres and was the largest of New York's conflagrations.

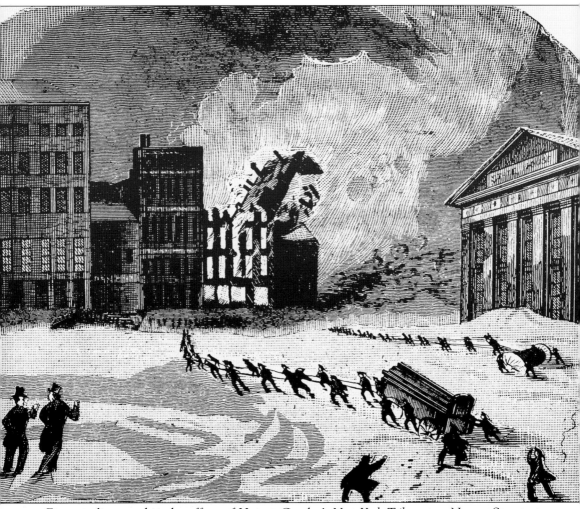

Fire was discovered in the offices of Horace Greeley's *New York Tribune*, on Nassau Street, at 4:00 on the morning of February 5, 1845. A blinding snowstorm buffeted the city, making many streets impassable and freezing hydrants. Many hand-drawn companies were trapped in quarters by heavy drifts. Jefferson Engine 26 placed their apparatus on a sled and drew it to the fire. During the 24-hour operation, the original building collapsed; however, nearby dwellings were spared due to the hard work of the firemen.

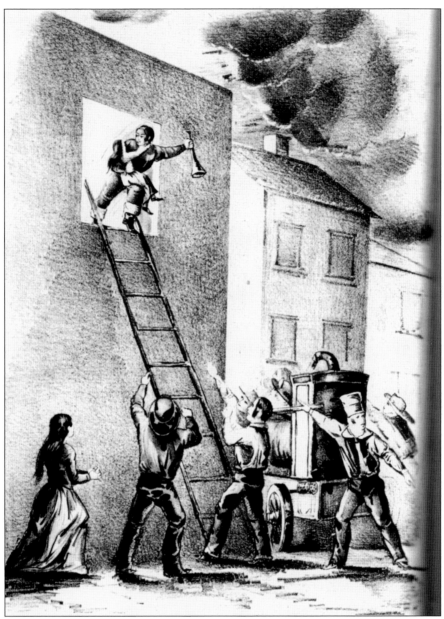

The Bowery Theater, located in the heart of what was then Manhattan's entertainment district, fell victim to arson on April 25, 1845. When the first engines arrived around 6:00 that evening, the theater was fully involved, and the outer walls were beginning to collapse. Within an hour, several adjacent buildings on Elizabeth Street were also burning, including several small tenements, two hotels, and a store. The popular working-class theater was rebuilt, as it had been on three previous occasions in 1828, 1836, and 1838. Actor and fireman Frank Chanfreau often portrayed Old Mose, "the King of the Bowery and the 5 Points," in plays at the Bowery Theater. Celebrated in plays and videos from the 1850s to the present, Moses Humphrey was reputed to be a member of Lady Washington Engine 40, located at Mulberry and Grand Streets. Fulfilling an image similar to the modern-day inner-city "tough", Mose the fireman was the stereotypical model for the Bowery B'hoy of his day.

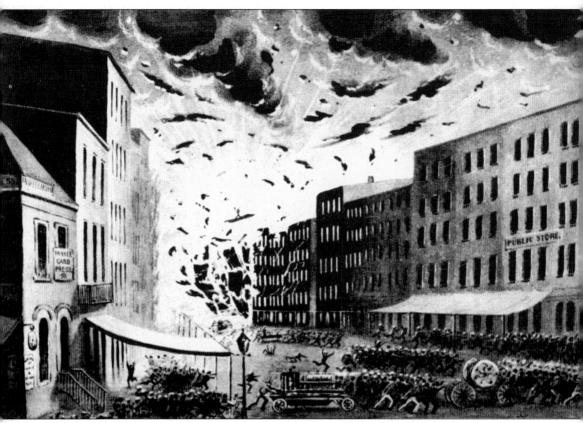

The rapid extension of a fire that broke out in a sperm oil store on New Street around 3:00 on the morning of July 19, 1845, triggered a massive explosion in a saltpeter warehouse on Broad Street ten minutes later. The blast was felt in Jersey City and Brooklyn, and as far away as Sandy Hook, New Jersey. Fireman Francis Hart, of Protector Engine 22 was propelled to the roof of an adjoining building by the force of the explosion and suffered a dislocated ankle. Augustus L. Cowdrey, a young lawyer and volunteer firefighter, was not so lucky. His body was never found. Cowdrey's memorial, along with others commemorating volunteer line of duty deaths, may be found in Trinity Church yard, facing Broadway.

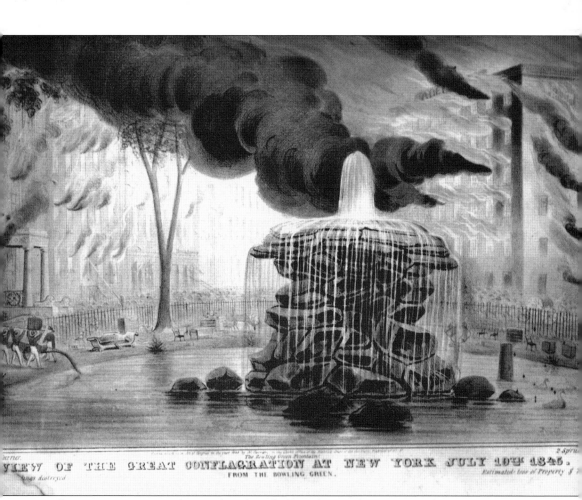

VIEW OF THE GREAT CONFLAGRATION AT NEW YORK JULY 19TH 1845.
FROM THE BOWLING GREEN.

In all, 200 structures were destroyed in the July fire. The area known as Bowling Green (as seen in this image), south of the explosion, was devastated. Mutual aid companies responded from Brooklyn, Williamsburg, and Newark, New Jersey.

A boiler explosion in a warehouse at 5–7 Hague Street, a tiny alley near the present-day Brooklyn Bridge, occurred on February 4, 1850. For more than 24 hours, firemen removed "basket after basket" of rubble to free more than 50 severely injured victims and at least 64 dead. This was the greatest loss of life in one incident to that date.

Many New Yorkers thought of their city as though it were a relatively small community, and accounts of the attempts to rescue several teenage boys working in the building were particularly heartbreaking. In the aftermath, private donations for "the fire sufferers" exceeded $27,000 in an age when most people made $1 a day. A well-attended "funeral for the unrecognized" concluded with the interment of several victims in Cypress Hills Cemetery in Brooklyn.

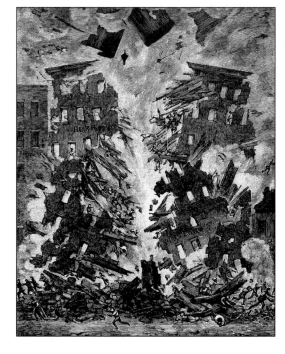

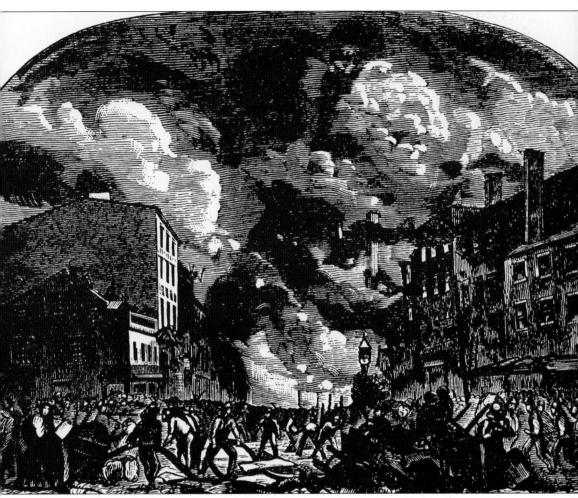

Around 10:00 on the morning of December 10, 1853, a worker at the publishing house of Harper and Brothers accidentally threw a match into a can of camphene, a chemical used to clean print rollers. As members of Mutual Ladder 1 rescued workers trapped in the upper stories, 600 employees fled the building. Despite the efforts of all the downtown companies, augmented by units from Brooklyn, Harlem, and Yorkville, the fire destroyed 16 buildings in the Franklin Square neighborhood.

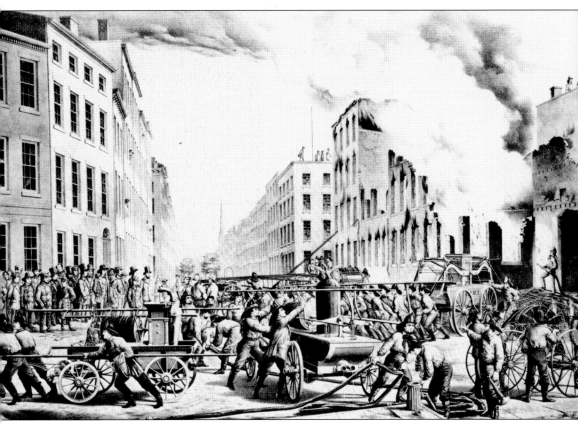

According to 19th-century fire historian J. Frank Kernan, the Currier and Ives print, *The Life of a Fireman: The Ruins–"Take up"–"Man Your Rope,"* depicts the final stages of the Harper and Brothers fire of December 1853. Completed by artist Louis Maurer in December 1853, just before the first steamers were purchased, the print depicts a well-organized and calm fire scene with hand-pumped companies conducting an exterior attack designed to prevent extension. Firemen can be seen disconnecting from a fire plug, leaving the scene, and putting water on the fire in front of the ever-present crowd of onlookers.

Shortly past midnight on December 27, 1853, a fire originating in a bakery on Front Street extended eastward toward the pier where the *Great Republic*, the largest cargo clipper ship ever built, was moored at Pier 28. Within minutes, the *Great Republic* (shown here under construction) and adjacent ships north and south of its mooring at the South Street Seaport were ablaze. In desperation, the ship was scuttled while everything above the waterline burned. Nonetheless, the ship was rebuilt and set out to sea once again in February 1855.

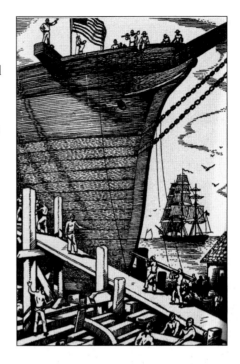

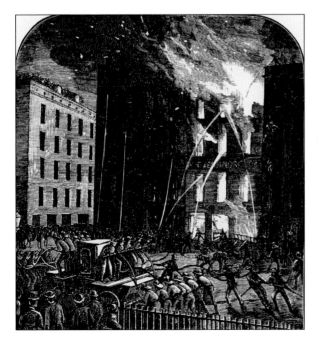

The fire and collapse of the W. T. Jennings clothing store, located on Broadway just above city hall, on the night of April 25, 1854, was the most deadly incident of the volunteer era. When a partial collapse of the lower floors trapped members in the basement and on the second floor, dozens of their comrades went to their rescue. The subsequent collapse of the weakened rear wall of the clothing store took the entire building down. In all, 11 firemen were killed and more than 20 others were injured.

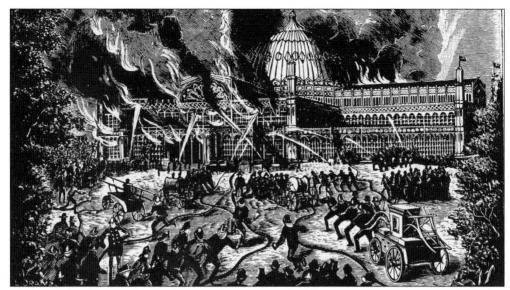

The Crystal Palace exhibition hall was home to the first American world's fair. Located between Fortieth and Forty-second Streets, east of Sixth Avenue, it burned to the ground in 30 minutes late in the afternoon of October 5, 1858. Even as fire companies swarmed in, setting up 20 to 30 exterior streams, the 12.5-story glass dome was collapsing. No lives were lost. However, almost 4,000 exhibits from all around the world were destroyed, along with numerous pieces of New York fire apparatus that were also on display.

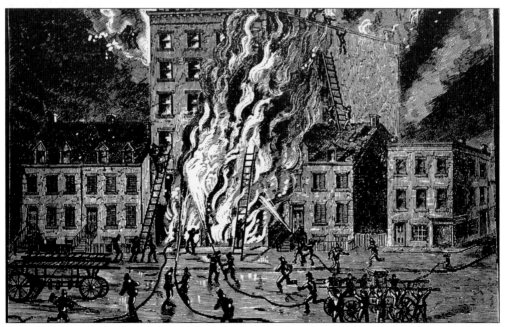

The Elm Street tenement fire of February 2, 1860, cost nearly 20 lives. Shoddy construction was to blame, along with the absence of any building codes, which endangered a population that grew from 313,000 to almost 814,000 in less than 20 years. In the aftermath of an increasing number of tenement fires that was capped by the Elm Street tragedy, the common council enacted the city's first fire escape law.

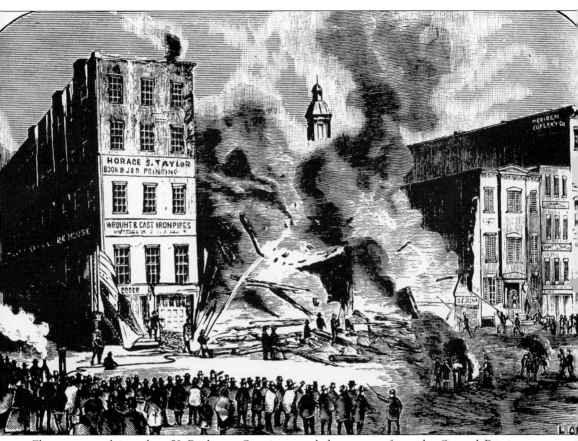

Flames were observed at 53 Beekman Street, several doors away from the Second Precinct Stationhouse, around 5:00 on the morning of December 29, 1859. The fire extended to adjoining paper warehouses along Beekman Street and into four other buildings on Ann and Fulton Streets. The collapse of a wall buried one of two engines from Protection Engine 5, which was operating at the scene, and this temporarily trapped several of its members, who were freed within a short time.

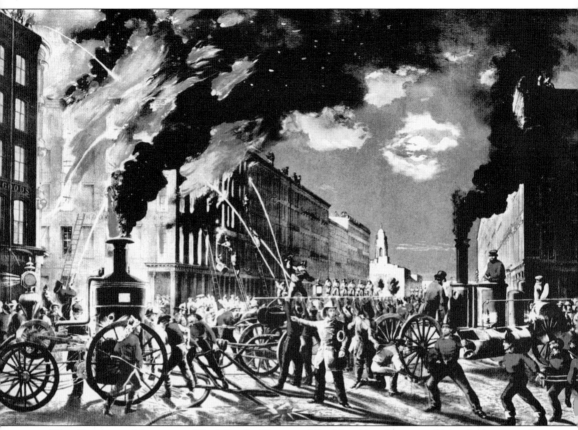

The Currier and Ives print *The Life of a Fireman: The New Era, Steam and Muscle* depicts a fire in a five-story building on the northeast corner of Murray and Church Streets on September 9, 1861. The alarm came in around 11:00 p.m., and before the fire was contained, seven buildings had been destroyed. In the center, John Decker, the last volunteer chief engineer can be seen carrying his speaking trumpet as he directs operations. A hand engine, Lady Washington Engine 40, works at mid-left, while on the right, the self propelled steamer known as the Exempt Engine rolls on to the scene. Manhattan Engine 8, on the far left, was nicknamed "the Elephant" because of its size and unwieldiness. It was the first practical mobile steam apparatus placed in regular service in New York. Its fuel consumption was so great that firemen had to scout the neighborhoods for packing boxes to keep the boiler going. A model of the Elephant is exhibited in the vestibule of the New York fire commissioner's office.

VOUCHER OF FOREMAN AND SECRETARY.

We, the undersigned, Foreman and Secretary of *Engine*
Co. No. *17* Do hereby Certify, that *John Boden*
is an *Exempt* member of said Company,
performing active duty therein, and has been drafted in the *5th* Congressional District of the State of New York.

S.T. Russell Foreman.

a. Stick Secretary.

New York, *Sept 7th* 1863.

It was not only race, but class, that ignited the Draft Riots of 1863. African Americans and Irish were traditionally pitted against each other for the lowest paying jobs. Battlefield casualties among immigrants and lower income families, mostly Irish and German, were disproportionately higher than other combat troops. New York's firemen were particularly outraged by the draft. Throughout their experience, they had been guaranteed exemption from militia and jury duty after seven years of volunteer service, and the draft represented a betrayal of a promise. New York's city government eventually "bought out" those volunteer firemen called up in the draft by finding substitutes as seen in the official forms above and below. There were similar uprisings in many other cities at the same time.

VOUCHER FOR SUBSTITUTES.

2266

I do hereby Certify, that *John Williams*
of No. *16 Hamilton St.* has been duly mustered into the
service as a substitute for *John Boden* of
No. *46 Suffolk St.*

Capt. John Safly,
Member of the Enrolling Board of
the *5th* Congressional Dist.

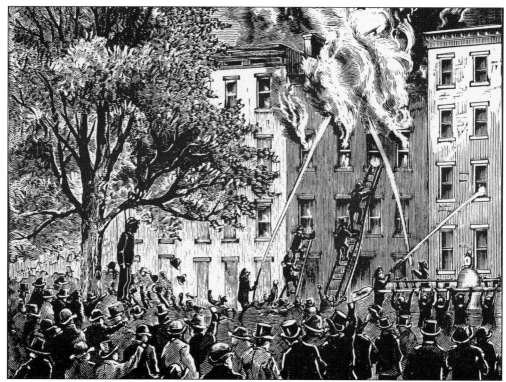

Most historians have erroneously endorsed the views of those hostile to immigrants in the 1860s, that the members of Black Joke Engine Company 33, quartered on Fifty-eighth Street on the Upper West Side, ignited the riots. Evidence to the contrary conclusively indicates that volunteer units, including Black Joke, immediately set themselves to fighting fires and the rioters. This image represents one of many similar scenes raging around the city.

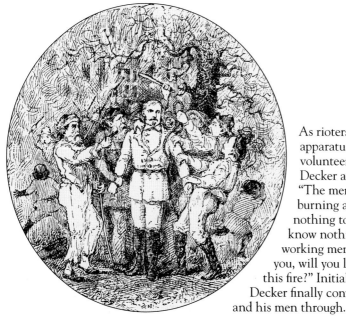

As rioters cut hoses, blocked apparatus, and physically fought with volunteer companies, Chief John Decker addressed the mob saying, "The men whose houses are now burning are innocent. They have nothing to do with the Draft. They know nothing of it. They are hard-working men like yourselves. Now I ask you, will you let us go to work and put out this fire?" Initially threatened with hanging, Decker finally convinced the crowd to let him and his men through.

At least a dozen people were killed when the mobs fired the imposing Colored Orphan Asylum on Fifth Avenue, which extended from Forty-third to Forty-fourth Streets. When Chief Engineer Decker attempted to get the crowd to disperse, he was knocked down twice and threatened with hanging. At last a number of firemen pushed through the crowd, attempting to effect some rescues, until they were forced back by the fire. During the riots, dozens of frightened African American citizens took refuge in firehouses.

Although rumors spoke of thousands, the admitted cost in human lives from the Draft Riots of 1863 is estimated to have been between 105 and 150, including 18 African Americans who were hanged, shot, or beaten to death. Between 125 and 150 citizens were officially reported injured. This "riot-damages-indemnity-bond" for $100,000 was likely one of several issued in an effort to create a fund to compensate those whose property was damaged or destroyed.

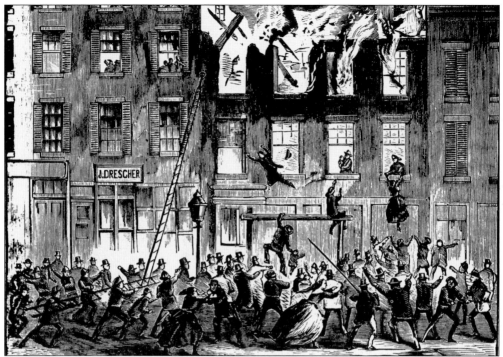

A family of seven was trapped by a quick-moving fire at 75 Division Street on May 29, 1864. The apartments shared the building with a secondhand furniture store and a cigar maker, demonstrating the dangers inherent in mixed occupancies. Foreman Francis Mahedy and members of Peterson Engine 31 affected multiple rescues. Mahedy was killed in the line of duty in 1886 while serving as a battalion chief in FDNY.

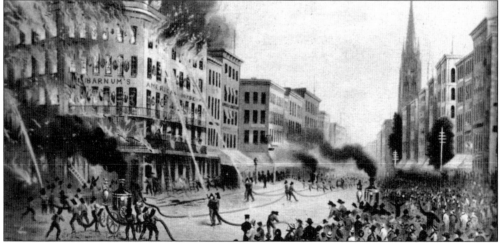

Occurring in a difficult period of transition from the volunteer department to the incoming paid Metropolitan Fire Department, the fire in P. T. Barnum's American Museum on July 13, 1865, rapidly extended to almost 20 buildings on Broadway, Ann, and Fulton Streets. Of the 57 volunteer companies who pledged to remain on duty until the transfer was complete, only 19 responded. Brooklyn brought over several steamers, while Hoboken sent two fire engines and two hose carriages.

Two

1866–1913

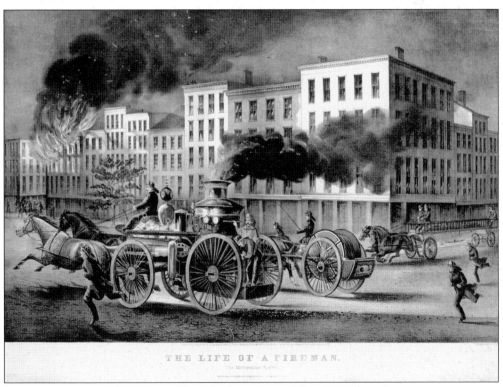

The 1866 Currier and Ives print *The Life of a Fireman: The Metropolitan System* conveys a sense of almost geometrical order, intense calm, and focus as compared to the exuberance and flair of the volunteer department. Three pieces of the newly constituted, New York State–controlled Metropolitan Fire Department, a horse-drawn steam engine, hose reel, and ladder are pictured. New apparatus failed to be designed with back steps or running boards large enough to enable fire crews to ride. The error was soon corrected.

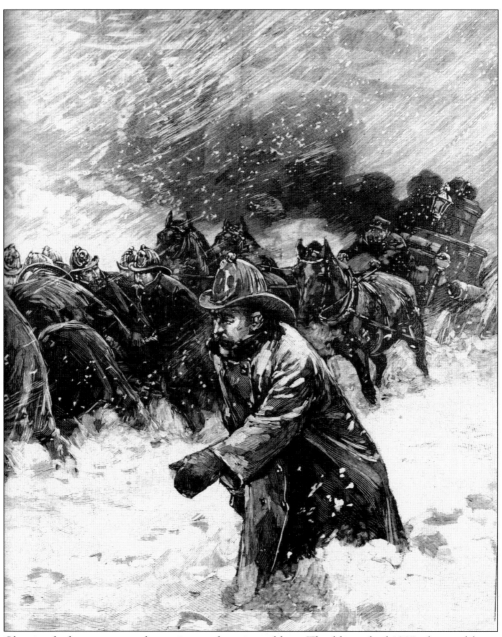

Clearing hydrants was, and remains, a chronic problem. The blizzard of 1888, depicted here, was the greatest of all blizzards. Years earlier, Fire Commissioner Alexander T. Shaler, the organizational creator of the paid department, was tweaked in a *New York Times* editorial for not ordering his men out to dig out hydrants after a severe storm in December 1867. In a forthright response, Shaler passionately defended his department, noting that given the fact that there were close to 3,000 hydrants to clear and so large a number of firemen were committed to patrol duty in their company districts, insufficient manpower was available for such a task. Rejecting the implication that his metropolitans were shirking their duties, Shaler testily wrote, "Any citizen can satisfy himself by spending twenty-four hours at one of our engine houses that the New York fireman of today eats no idle bread."

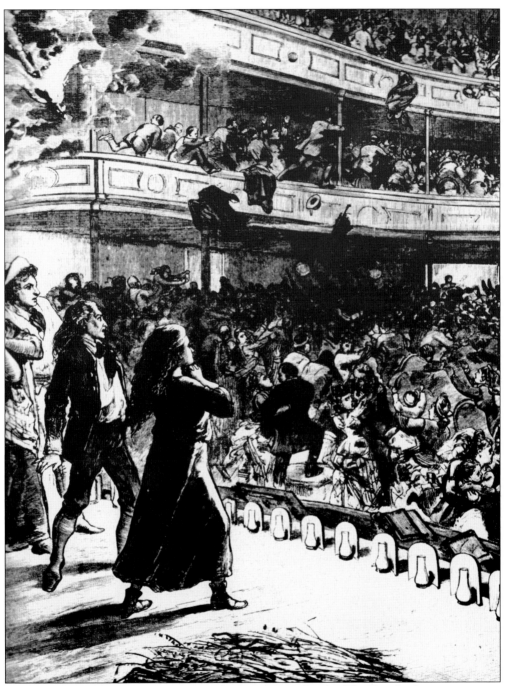

Just after 11:00 on the evening of December 6, 1876, as the play *The Two Orphans* was coming to a close at Conroy's Theater on the corner of Johnson and Washington Streets in downtown Brooklyn, flame from an oil lamp caught the top of a canvas curtain. As the fast-moving fire rose to the roof of the interior, actress Kate Claxton took center stage in an effort to calm the crowd and direct an orderly evacuation.

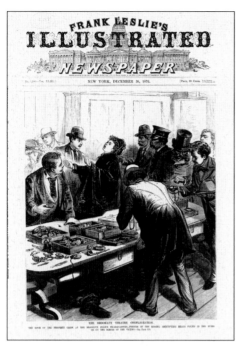

Kate Claxton's gesture was futile. The audience of 1,000 or more panicked and headed for the all-too-few exits. Firemen began removing a total of 295 bodies from the wreckage around 3:00 the next morning. The sad task of looking for victims' belongings fell to relatives, as is seen in this view.

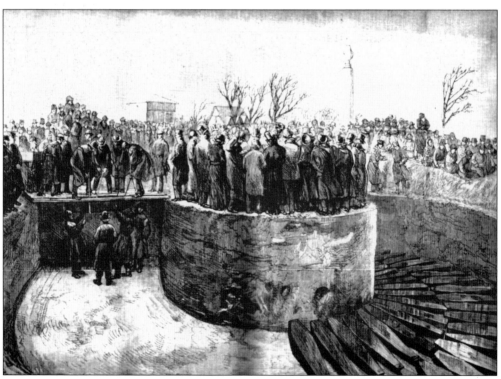

Arranged in a radiating double circle around the base of a 30-foot-tall obelisk erected by the City of Brooklyn, the coffins of 103 unclaimed victims are buried in a memorial plot in Greenwood Cemetery. The fire precipitated the enactment of stricter laws governing safety in places of public assembly.

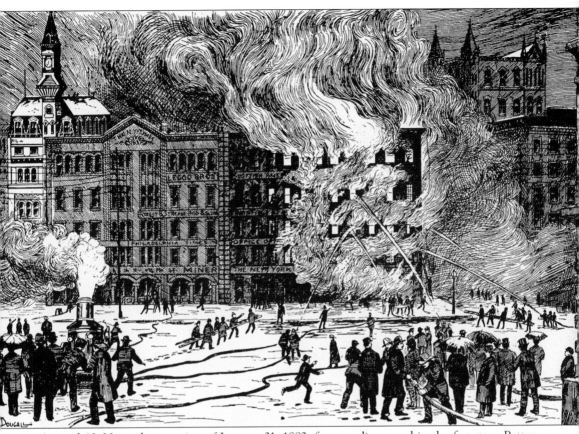

Around 10:00 on the morning of January 31, 1882, fire was discovered in the five-story Potter Building, located in the heart of "Newspaper Row," occupying the entire block bounded by Park Row, Beekman, Spruce, and Nassau Streets. Arriving companies were challenged by an intensifying snow and sleet storm, low water pressure, overhead electrical and telegraph wires blocking access, and all-too-short ladders. To one first-alarm fire officer, the building itself, honeycombed by long and narrow wooden hallways and an open stairwell from the lobby to the top floor, looked as if a "powder magazine" had exploded. Fireman John L. Rooney of Ladder 10 was awarded the James Gordon Bennett Medal for multiple rescues. In the aftermath of more than 12 civilian deaths, the fire department began issuing ladder companies "pompier," or scaling ladders, doubled up some downtown units, and pressed for reforms in building codes and enforcement. The Potter Building fire was the focus of Jack Finney's novel *Time and Again*.

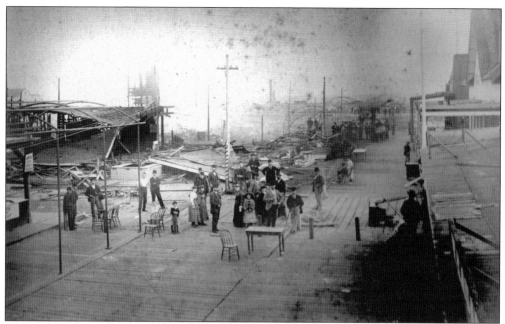

Fire broke out in the Seaside Museum on the windswept Rockaway Peninsula around noon on Tuesday, September 20, 1892. In a "disastrous economy" in the mid-1880s, the solitary engine stationed on the peninsula had been dismissed as "too expensive." Flames raged uncontrolled as nine nearby towns sent 19 hose and ladder companies, but no engines.

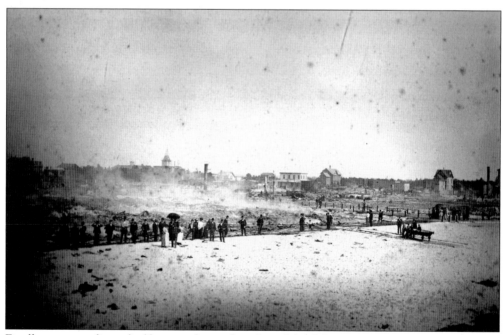

Finally a steamer dispatched by special train from Long Island City went to work around 3:30 p.m. Before it was over, the heart of the community, more than 20 square blocks of flimsily-constructed buildings, was destroyed in a little over six hours. The area was soon rebuilt as a working-class summer haven, becoming known as the Irish Riviera.

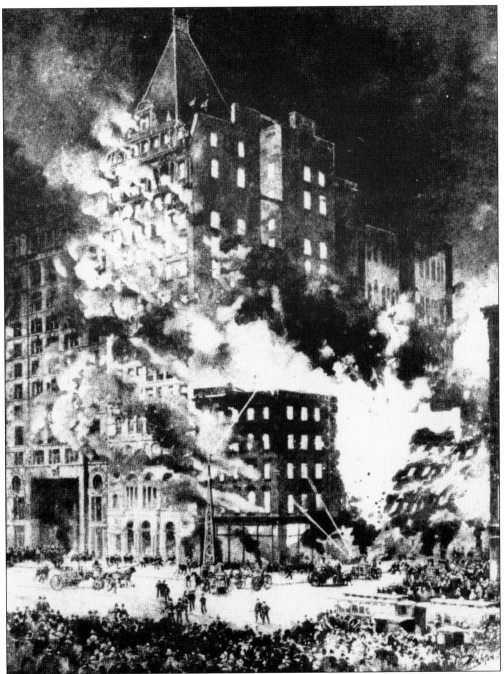

On December 4, 1898, heat from an intense fire in the 5-story Rogers Peet Building at the corner of Broadway and Warren Streets in lower Manhattan melted the unprotected, plain glass windows of the 16-story building just to its south. The 6th to the 16th floors of the adjoining Home Life Insurance Company became involved in what is considered to have been New York City's first real "high rise" blaze. The Home Life's interior standpipe system ruptured when it was unable to hold up under the heavy volume and pressure. The nearby Postal Telegraph Building farther south suffered heavy damage from the 12th to the 14th floors.

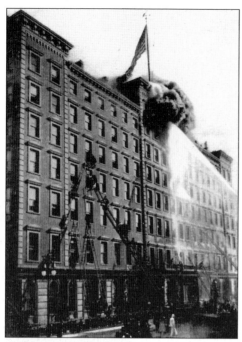

As marchers during the St. Patrick's Day parade passed the Windsor Hotel around 3:20 p.m. on March 17, 1899, a match thrown by a careless smoker lit up a window curtain. Responding apparatus had a hard time making their way through heavy crowds into the fifth alarm. Despite the availability of heavy-duty fire escapes, many guests and workers jumped from upper floors.

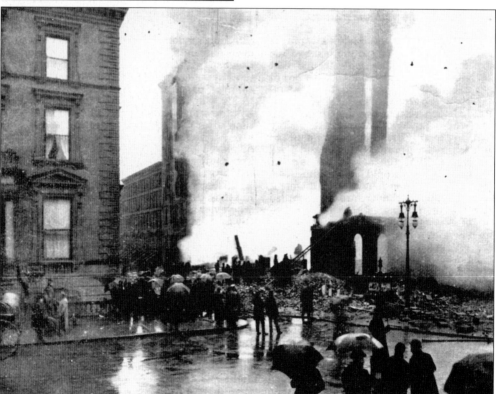

By late afternoon, the building had collapsed. Even as firemen maintained their watch lines, the search through the rubble began. It went on for days, as police kept both curious onlookers and petty thieves at a safe distance. The death toll reached 92.

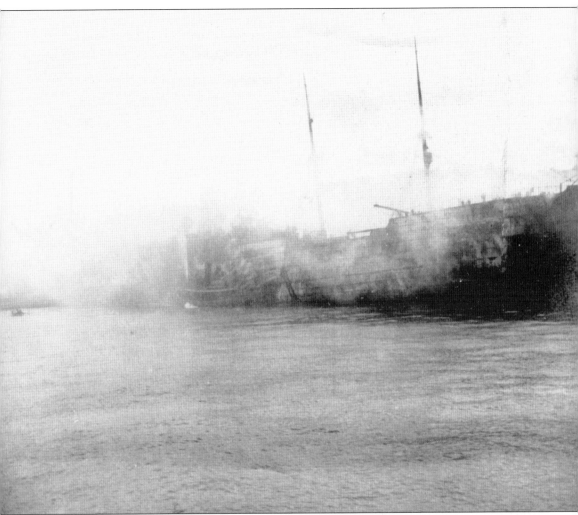

Around 4:00 p.m. on Saturday, June 30, 1900, as a delightful early summer day was coming to a close in Hoboken, New Jersey, fire was discovered on Pier 3 in bales of cotton. Fanned by a stiff wind from the south, flames soon spread to coal barges, lighters, and six ocean-going ships. On the landside, the fire extended to several large warehouses, railroad cars, and four additional piers. Within minutes, FDNY fireboats *Van Wyck* and *New Yorker* set out for the scene. Hundreds of longshoremen, stevedores, and weekend visitors aboard four cruise ships were trapped. The *New Yorker* worked on the *Bremen*. For hours, the faces of dozens of people trapped below decks were seen at the eleven-inch portholes of the *Saale*, *Bremen*, and *Main*, screaming in vain for rescue.

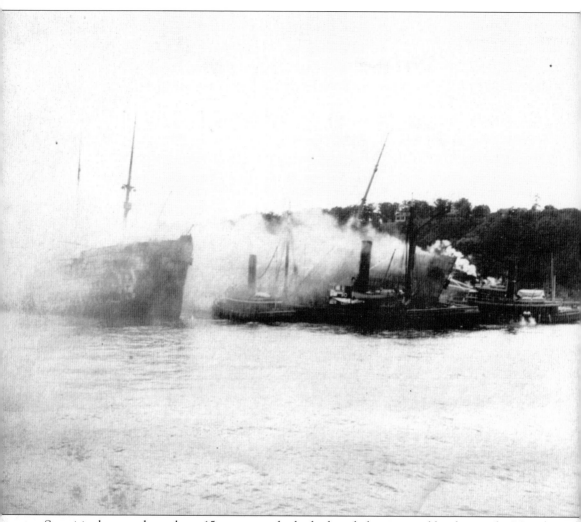

Surprisingly, seven hours later, 15 crewmen who had taken shelter in a coal bunker on the *Main* were rescued. The 4-stacker *Kaiser Wilhelm der Grosse*, the pride of the North German Line, was the only ship saved. Two ships were dragged to the Weehawken flats and permitted to burn out. Another was eventually sunk at Communipaw, now a part of Jersey City. The *Kaiser Wilhelm der Grosse* moved to a Cunard pier on the Manhattan side of the river and sailed as scheduled on Tuesday, July 3, 1900, with its staterooms full and carrying 400 crew members from its sunken sister ships. On its way out of the harbor, the *Wilhelm* passed the burned-out hulk of the *Saale*, where divers were still searching for bodies. It is estimated that nearly 400 people died in the disaster.

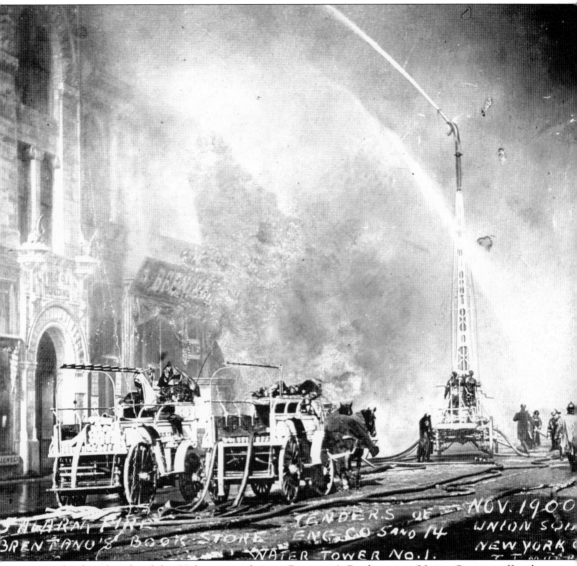

As the first decade of the 20th century began, Brentano's Bookstore at Union Square suffered major damage from fire. More than a "fire buff," publisher Simon Brentano was closely related to FDNY in the late 19th century. After meticulously compiling statistics on fire frequency in neighborhoods, Brentano testified before a tenement house commission hearing, "if you want to know where the poor people live, just find out where the fires are." He and Dr. Harry Archer consistently supported departmental efforts to modernize and to reform fire codes.

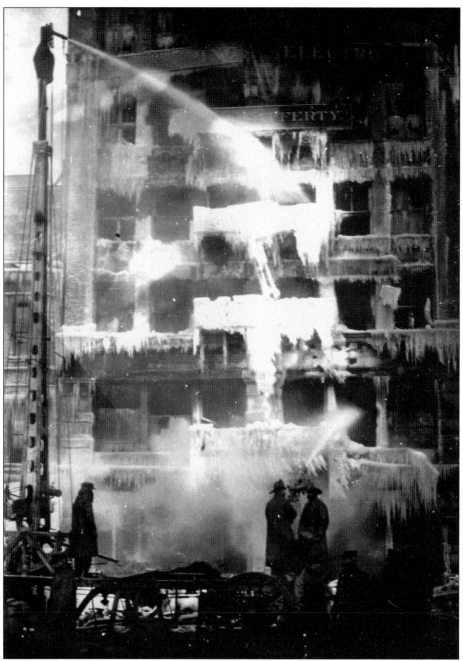

The seven-story Boston Excelsior warehouse in the Bowery burned on January 18, 1903. Access was impeded by iron doors, as well as loaded and locked trucks. One fireman was crushed to death by a falling bale of excelsior, a highly flammable packing material, in the later stages of the operation. The second FDNY line of duty death that year was that of Capt. John T. Andariese of Engine 1, who was killed on February 26, 1903, at a four-alarm blaze at Broadway and Thirteenth Street. Of the fallen captain, Chief Purroy said, "There was never a better man in the department than John Andariese and I never heard any one speak an ill word of him." Captain Andariese was the great-granduncle of Glenn Corbett, the coauthor of this volume.

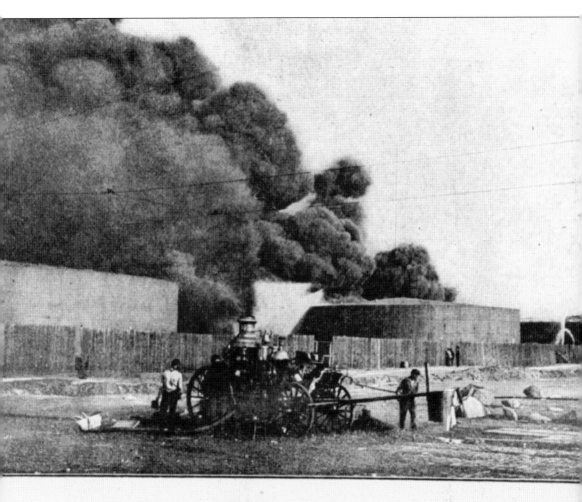

A WATER-FRONT FIRE FROM THE LAND SIDE

On January 7, 1903, a Standard Oil facility was faced with a potentially dangerous situation after a crew member threw hot ashes over the side of his canal boat, which was tied up to a dock on the East River in Brooklyn, and lit up his own craft. Fire extended to the landside at the foot of Thirteenth Street, fed by pools of oil on the surface and communicating to a feeder line connected to a tanks containing almost 3,000 barrels of naphtha. Brooklyn units contained the fire before the tank itself became involved.

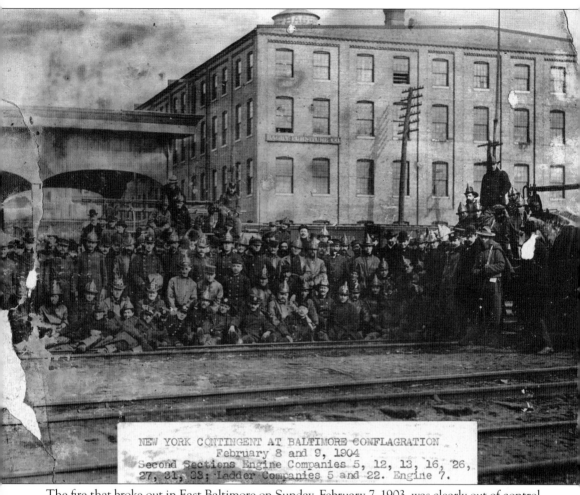

NEW YORK CONTINGENT AT BALTIMORE CONFLAGRATION
February 8 and 9, 1904
Second Sections Engine Companies 5, 12, 13, 16, 26,
27, 31, 33; Ladder Companies 5 and 22. Engine 7.

The fire that broke out in East Baltimore on Sunday, February 7, 1903, was clearly out of control from the onset, and the city called for mutual aid. Within hours, companies showed up from Washington, D.C., Philadelphia, York, Chester, Harrisburg, and Altoona, Pennsylvania, and Wilmington, Delaware. In the early hours of February 8, nine FDNY engines and a ladder company, their horses, and personnel under the command of Battalion Chief John Howe and accompanied by the indefatigable department medical officer Dr. Harry Archer, were transported by ferry from lower Manhattan to Jersey City. They departed by train from Jersey City around 6:20 p.m., made a brief stop in Philadelphia, and arrived in Baltimore just after midday. On the journey, a number of firemen observed that they had never been farther away from the city than Coney Island, Hoboken, and Weehawken. New York units were immediately assigned to contain widespread coal and lumber fires, continuing operations through Tuesday. Shortly after their return, a member of Ladder 5, exhausted by his duties in Baltimore, died of pneumonia. On a happier note, Engine 16 came back with a mascot, a puppy that had adopted them in the streets of the beleaguered city. They named him Baltimore.

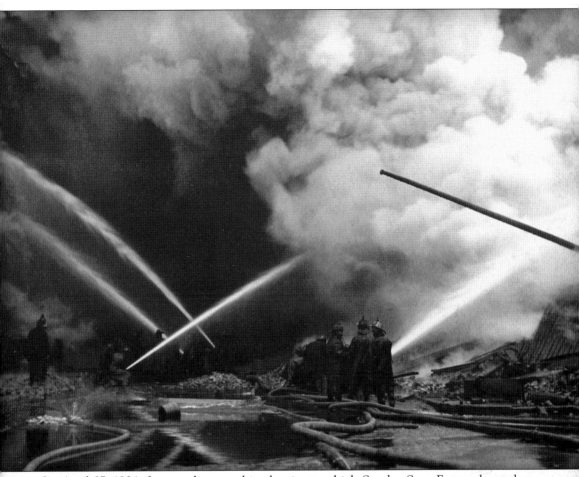

On April 27, 1904, fire was discovered in the six-story-high Stanley Soap Factory located on Thirteenth Avenue between West Twenty-ninth and Thirtieth Streets around 1:30 a.m. A similar incident, 19 months earlier, took the life of one employee. Once again, responding companies were faced with continuous explosions of oils and chemicals as they placed heavy stream deluge sets around the building. Three firemen working a hose line in an aggressive location were killed by a falling wall soon after 5:00 a.m., despite being warned of the danger by Chief of Department Edward F. Croker at least an hour earlier. The three were from Engine Company 19, located on West Twenty-fifth Street. All were rather new in the job, and one was still "probie." They were the first men lost under Chief Croker's command. The fire consumed the entire square block, including a coal yard and lumberyard, and it seriously damaged the exposures on all sides.

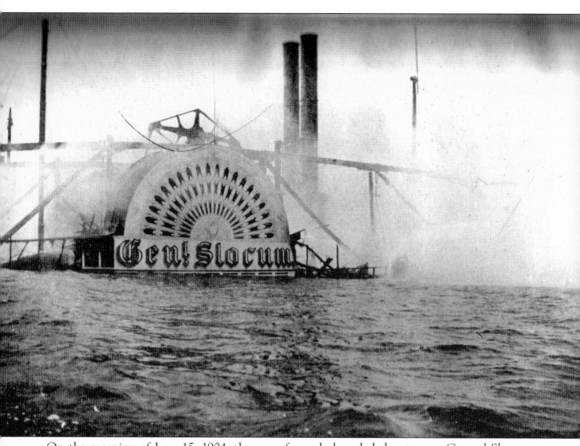

On the morning of June 15, 1904, throngs of people boarded the steamer *General Slocum* at the Third Street "recreation" pier on the East River. Many of the estimated 1,500 people were women and children from St. Mark's German Lutheran Church on Manhattan's lower east side, who were looking forward to their picnic excursion to Locust Grove on Long Island Sound. Under the command of Capt. William Van Shaick, *General Slocum* proceeded up the East River, passing Hell Gate when a fire was detected at the bow under the main deck.

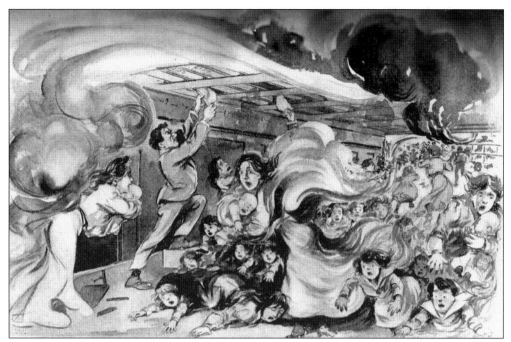

The fire, which began in a storeroom, spread quickly below deck. Firefighting pumps and hose failed miserably, having not been inspected for years. Above deck in the pilothouse, Captain Van Shaick continued to steam ahead instead of beaching the burning ship to get the passengers off.

People were forced to the edge of the main deck in an attempt to flee the flames. The desperate souls attempted to use the rotten, cork life preservers, which proved useless. Many individuals were forced to jump in the fast-moving current to avoid the flames. This proved deadly to many women with long dresses and children, most of whom could not swim.

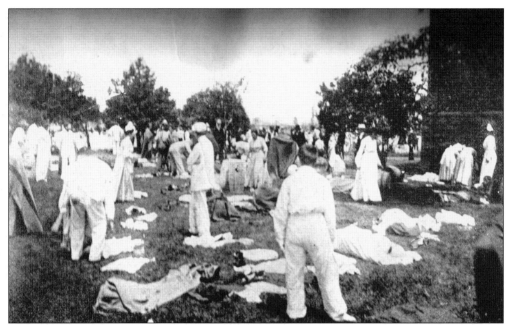

Capt. William Van Shaick finally beached the *General Slocum* several feet from the shoreline of North Brother Island, home to an isolation hospital (where the famous Typhoid Mary was confined in 1907). Doctors, nurses, and patients went to the shoreline to pull in victims. Watching near 138th Street, land-based fire companies stood helplessly. Unfortunately many victims were beyond revival and were lined up at the water's edge.

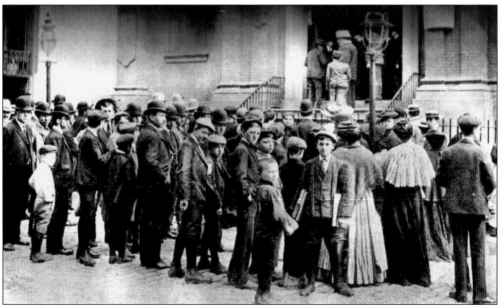

After the disaster, many families were frantic for news of their loved ones. Some went to St. Mark's Church for news, as is seen in this photograph, while others went to the temporary morgue at the East Twenty-third Street Pier. The final death toll stood at 1,021, the worst disaster in New York's history prior to September 11, 2001.

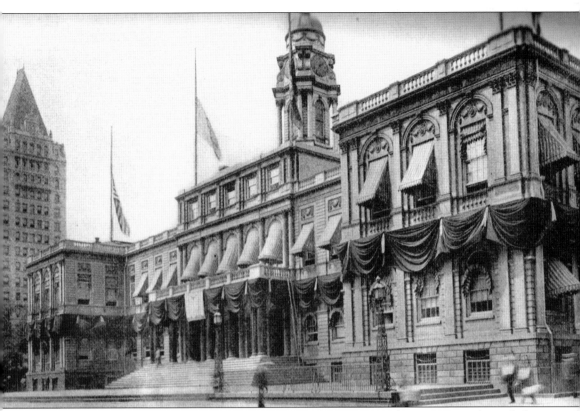

The city went into mourning. City hall was draped in bunting. Over $100,000 poured in to help the survivors. Monuments were erected in Tompkins Square Park and All Faiths Cemetery in Middle Village, Queens, where some of the victims were buried. Captain Van Shaick was tried and convicted of negligence and manslaughter, and he was sentenced to spend 10 years in Sing Sing Prison. He was pardoned by President Taft after serving only three years of his sentence.

The most notorious factory fire in American history occurred in the Triangle Shirtwaist Company on Saturday afternoon, March 25, 1911. Occupying the top 3 of the 10 floors in the Asch building at the northwest corner of Washington and Greene Streets, Triangle employed almost 500 people, mostly Jewish and Italian immigrant women between the ages of 13 and 23. Many Orthodox Jews were working on their Sabbath out of sheer economic necessity. The fire broke out on the ninth floor shortly after 4:30 p.m. and spread rapidly.

Dozens on the ninth floor died, unable to force open a locked exit door. After the elevator stopped working, some workers tried to slide down the remaining cables but lost their grip. The rear fire escape collapsed, killing many and eliminating an escape route. More than 50 women jumped to their death from open windows, with their burning dresses streaming behind them.

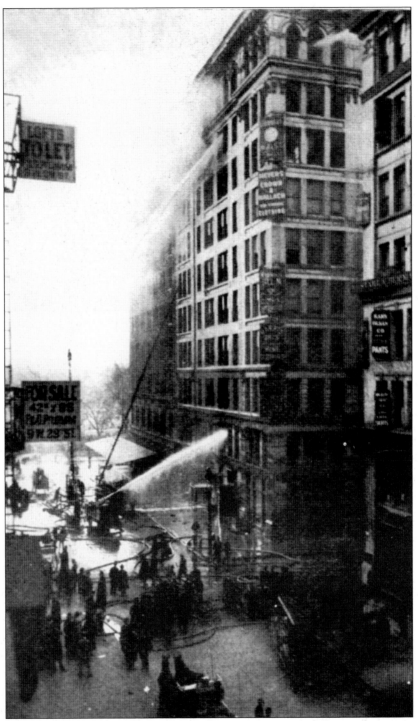

Ladder 20, first due on what turned out to be a fourth alarm, was hampered by the bodies of victims on the sidewalk and endangered by jumpers from upper floors. The men soon found that the life nets were unable to hold groups of three or four jumpers, and the truck's aerial ladder was unable to reach above the sixth floor.

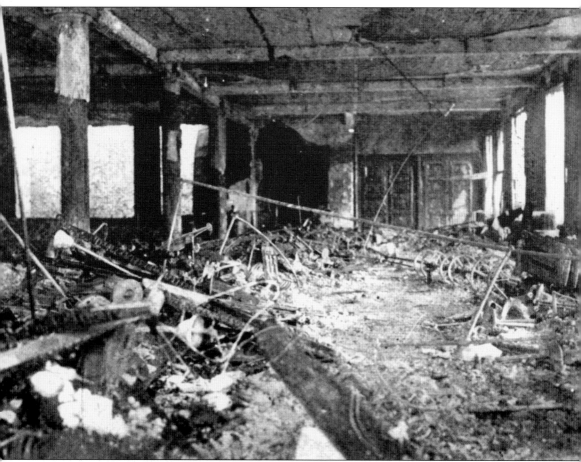

The floor of origin was a veritable tinderbox. As was the case with most sweatshops of the day, discarded flammable materials were carelessly piled up around the machines, some workers smoked in the work area, and the rooms were lit by gas lamps.

The remainder of the fifth-alarm assignment quickly contained the fire and placed it under control. It is clear that some members of Ladder 20, one of the companies assigned to recover the bodies of the dead, were suffering from post-traumatic stress disorder when they returned to quarters.

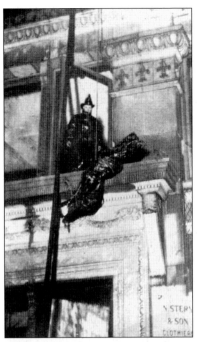

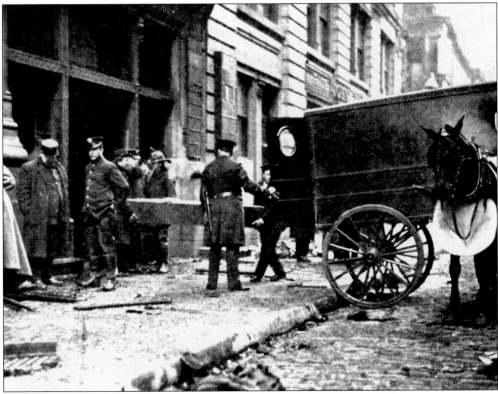

As was the policy in mass casualty incidents, the bodies, 123 women and 23 men, were taken to the Manhattan Charities Pier at the foot of East Twenty-sixth Street, more commonly known as Misery Lane.

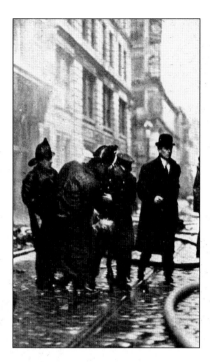

The event focused and galvanized the labor movement, was instrumental in strengthening the International Ladies' Garment Workers Union, inspired immediate legislative reforms in New York State, brought New York reformer Robert F. Wagner to national prominence, and influenced Franklin D. Roosevelt's New Deal. The Triangle fire illustrated the need for the enactment of strict regulations guaranteeing safe environments for workers.

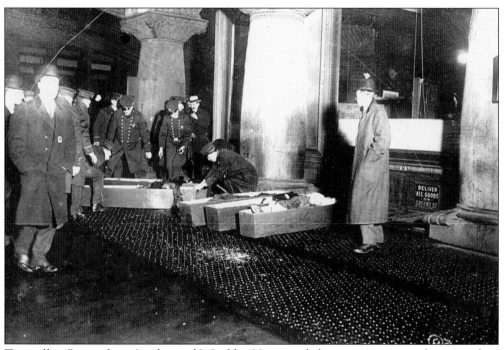

Tragically, 47 years later (to the week), Ladder 20 responded once again to another sweatshop fire in the same neighborhood, at the Monarch Textile Company, in which 24 mostly Hispanic, young immigrant women died.

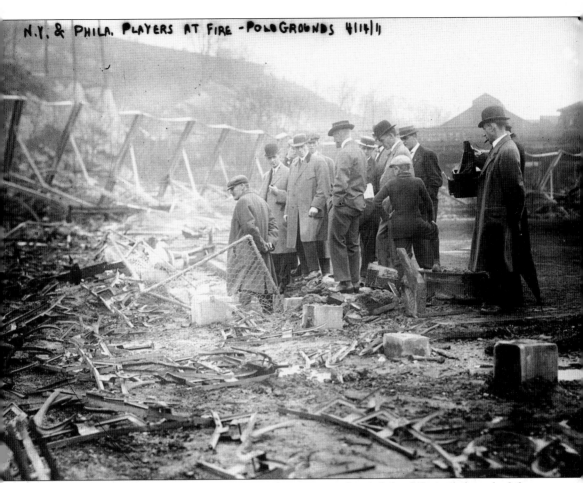

New York Giant and Philadelphia Athletic players view what is left of the grandstand of the Giants' baseball stadium, which burned to the ground on Holy Thursday, April 13, 1911. Two days later, a local columnist commented that "Maybe it was a good thing that the fire at the Polo Grounds burned up the Giants' bats. With a new collection of smooth ash stick the homeless team won its first victory of the season at American League Park." That same day, the Giants got a 25-year lease on the Polo Grounds on Coogan's Bluff, at 155th and 8th Avenues, after promising to build a new facility. For about two months, the Giants shared Hilltop Park, then the home of the New York Yankees, then located on the present site of Columbia Presbyterian Medical Center.

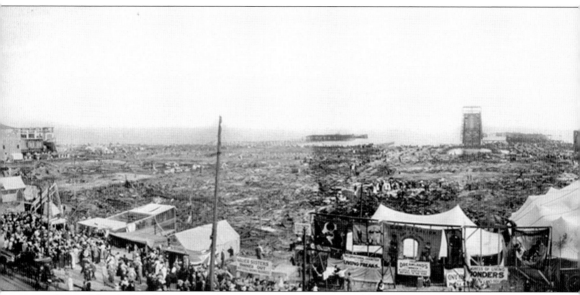

Coney Island, the playground of New York City, was visited by fire on numerous occasions. Its three fabled amusement parks—Steeplechase, Luna Park, and Dreamland—were each reduced to rubble through their history. Here we see the Dreamland fire of May 27, 1911, in a panoramic

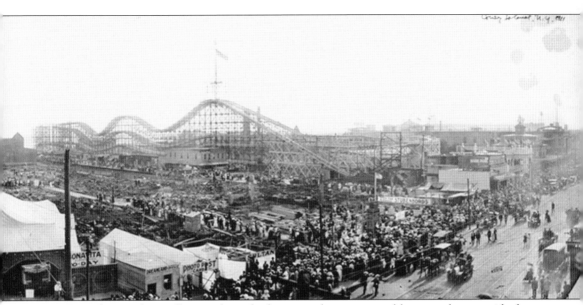
view. Note the wooden walkways through the ruins that were quickly erected to provide for tours, of course for a fee.

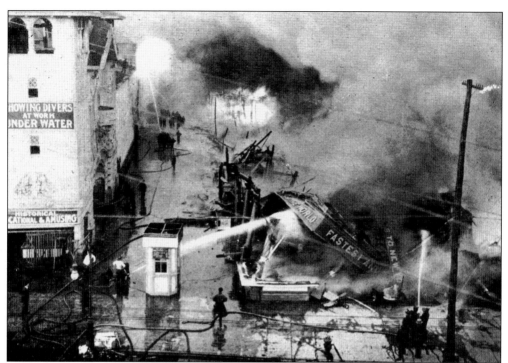

The 1911 fire started during the night of May 27, in an attraction known (ironically) as the Hell Gate. This is an image of the fire along Surf Avenue later in the morning.

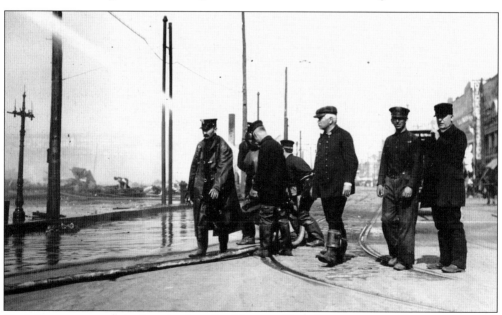

Firefighters pour water on the ruins from Surf Avenue. Complaints came in of low water pressure from fire hydrants in the highly touted Coney Island "high pressure system," which was newly installed and capable of supplying 5,000 gallons per minute to handle the biggest of blazes; another similar system had been put in lower Manhattan. The low pressure was likely due to too many hydrants being operated simultaneously.

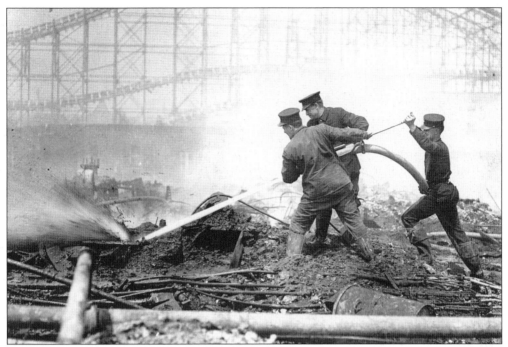

Firefighters use hoses to bore into the smoldering ruins. They worked for many hours before finally extinguishing the fire, as seen here and on the front cover of this book. A roller coaster is seen in the background.

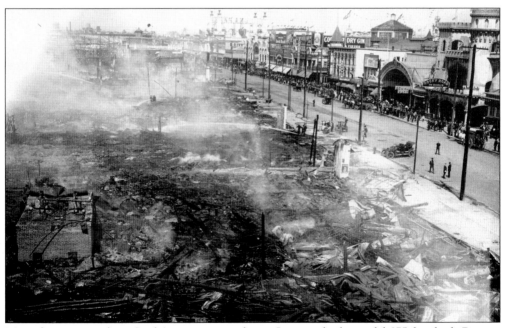

More devastation along Surf Avenue is seen here. Gone is the beautiful 375-foot-high Beacon Tower, the biblical "Creation" exhibit, the shoot-the-chutes ride, and the Lilliputian City of 300 midgets. Ironically, its amusements included a live-action show entitled "Fighting the Flames," seen in the next image.

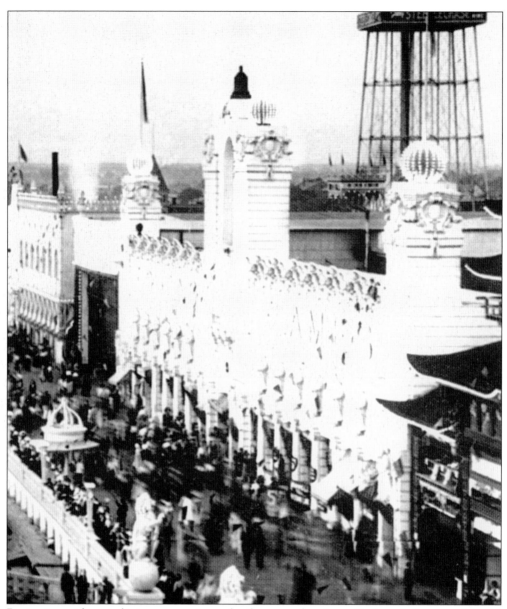

Beginning with two distinct attractions, the first staged at Luna Park and the second by its competitor, Dreamland, both shows opened in 1904 and continued at Freedomland in the Bronx 50 years later. The reenactment of fires was a popular theme at entertainment parks throughout much of the 20th century. Dreamland's exhibition, "Fighting the Flames," employed hundreds of firemen to engage in the imaginary rescue of occupants trapped in four-story tenements. Ladders were placed, victims jumped from upper floors, and everyone was saved. The performance may have been somewhat emotionally reassuring to many watchers who truly lived under very dangerous circumstances.

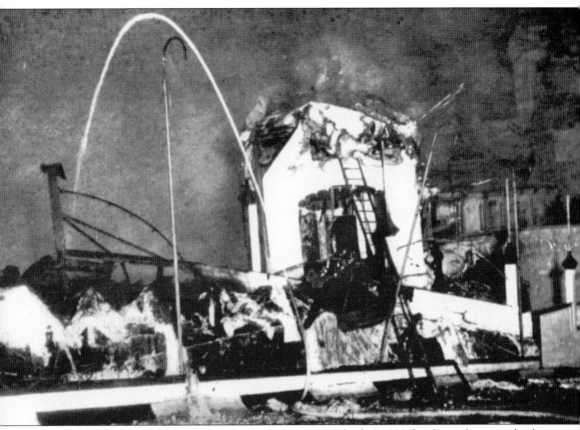

Coney Island's Luna Park burned on December 11, 1911. The $150,000 fire shown here involved show scenery, a pneumatic tube ride, the Alhambra restaurant (were the fire started), and an inclined ride called Checkers. The park was later destroyed by fire in the hot summer of 1944.

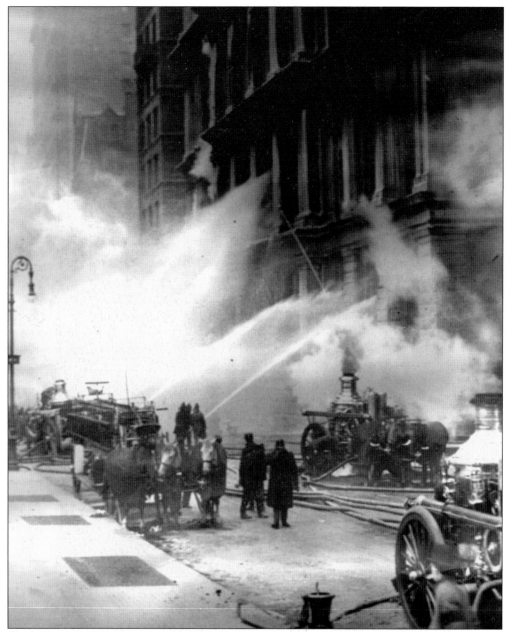

On January 9, 1912, the Equitable Life Insurance Building, actually several buildings ranging from 8 to 10 stories, constructed at different times and covering the block bounded by Broadway, Cedar, Pine, and Nassau Streets, was gutted by fire. For more than 20 minutes following its discovery, employees in the Equitable Building fought a fire that originated in a basement office, without calling the fire department.

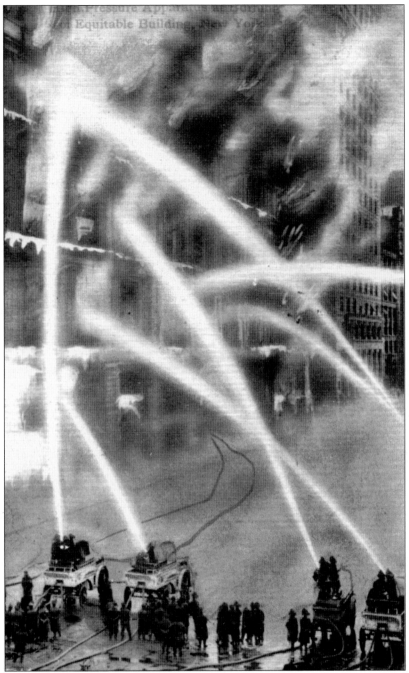

As the blaze extended vertically via the elevator shaft and horizontally in the absence of fire stops between the buildings, a first alarm went out at 5:34 a.m. Within an hour, it had escalated to a fifth alarm. At 7:48 a.m., Chief John Kenlon called additional units across the Brooklyn Bridge for the first time since the two great cities had "consolidated" into the Greater City of New York in 1898. By 9:30 a.m., the fire was under control. By the evening, high intensity lights were placed on the roof of the adjoining 47-story Singer Building as firemen attacked deep pockets of fire still banked down in the rubble.

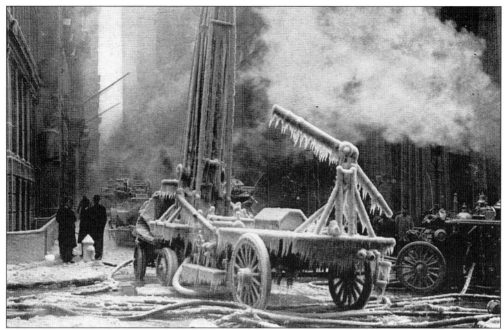

Conditions at the scene were appalling. As the day wore on, with winds around 40 miles per hour and the temperature falling to zero degrees, the streets were soon covered with a treacherous six-inch coating of ice.

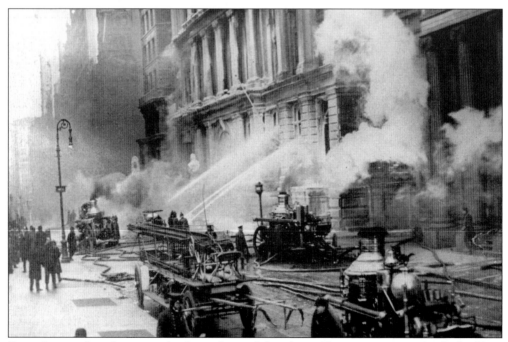

Several trapped civilians were hacksawed out of their barred basement rooms. As the building began to fall apart, Second Battalion Chief Walsh and 14 volunteers conducted a final search from the fourth floor down. Walsh did not make it out. Four days later, his frozen body was recovered from the collapse zone.

The rubble-filled streets immediately around the fire were deserted. All public transportation from hansom cabs to trolleys south of site was brought to a halt.

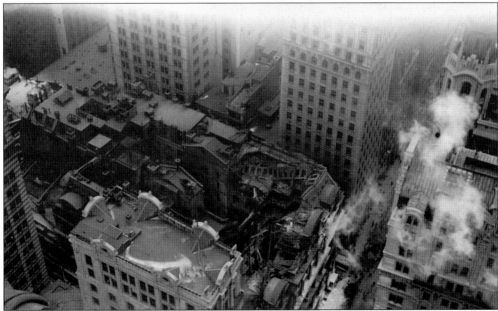

Six lives and millions of dollars in property were lost. In the aftermath, Rescue Company 1 was established, equipped with effective acetylene cutting tools. Construction regulations affecting office buildings were revised. On Medal Day the following year, the board of merit cited five firemen for their conduct, including fireman Seneca Larke, a member of the Seneca tribe and the only Native American in FDNY to receive the James Gordon Bennett Medal for Heroism.

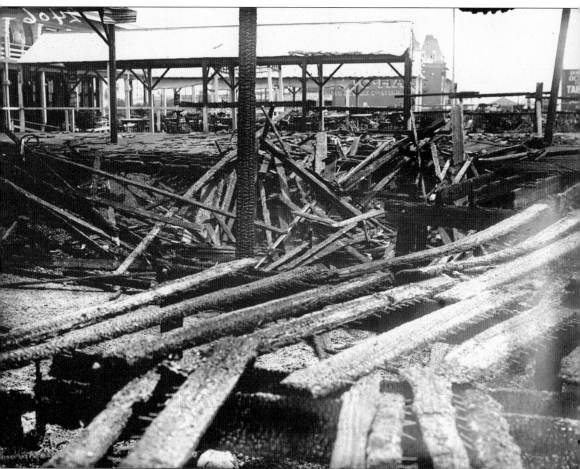

On June 5, 1912, fire erupted from a photographic shed on Brighton Beach's boardwalk near the Parkway baths. A swift south wind pushed the fire into a two-story wood frame restaurant and soda stand, as well as the Ocean Hotel.

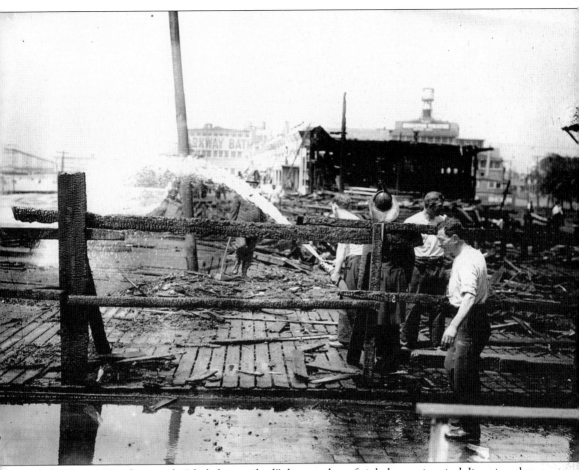

The Ocean Hotel was only "slightly scorched" due to a beneficial change in wind direction that forced the fire back toward the boardwalk. In all, about 75 feet of the walkway was destroyed.

On August 20, 1913, three workers were seriously injured and 62 were trapped when a fire broke out in a 450-foot-deep shaft connected to a new water tunnel of the Catskill Aqueduct. The tunnel was under construction at 149th Street and St. Nicholas Avenue when a fire in a blacksmith's shop at the head of the shaft broke out at 5:20 p.m.

Radiant heat from the surface fire was so intense that the window casings on a block of seven nearby apartment houses lit up. One hundred families were evacuated more than two blocks away. With the exception of one building that lost 18 apartments, the fire was contained to the fronts of the other structures.

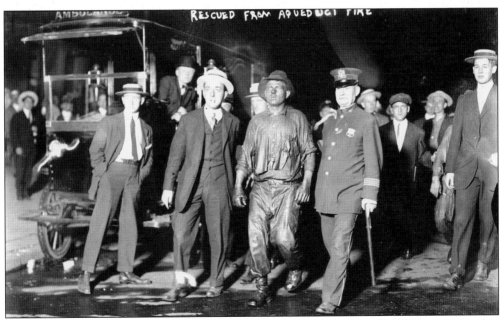

Complicating the situation below ground was the presence of 900 pounds of dynamite stored in a nearby magazine. John Kenlon, chief of department, transmitted a third alarm and summoned ambulances from three nearby hospitals. A rescue team including Kenlon, a captain, a lieutenant, and three firemen descended to the trapped men at the bottom of the shaft. All suffered from smoke, heat, and oxygen deprivation.

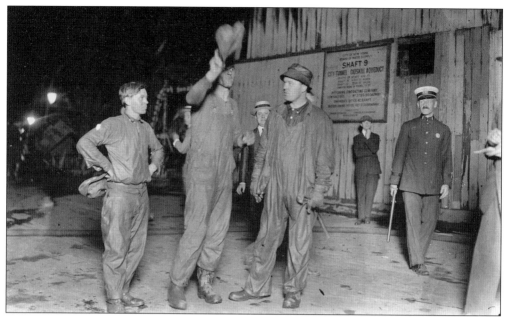

Shortly after 11:00 p.m., the first trapped men were able to get to the surface. Members of a nearby Saint Nicholas Avenue family, Carol, Helen, and Rose Pillis, "served coffee, tea, and sandwiches" to people at the scene.

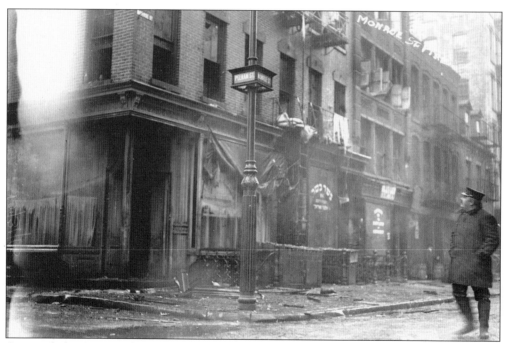

A second-alarm arson job that was set in a tenement on Monroe Street in the early hours of the morning of New Year's Eve 1913 cost the lives of eight tenants. A chauffeur returning from work saved both of his infirm parents, while a saloon keeper hailed a passing milk wagon and ordered the driver to back up against the building, enabling a dozen trapped tenants to jump to safety from the second floor.

Three

1914–1944

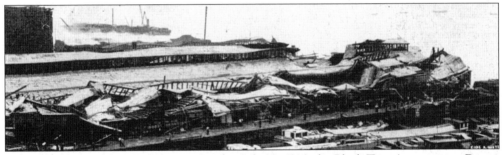

Beginning shortly after 2:00 a.m. on Sunday, July 30, 1916, the Black Tom Ammunition Depot, located on an island between the Statue of Liberty and the present-day Liberty State Park in Jersey City, began to explode. Windows blew out in lower Manhattan and as far north as Times Square as more than two million pounds of ammunition went up. The reverberations were felt as far away as Connecticut and Maryland. A dud shell went down the smokestack of the New York fireboat *William T. Strong* as it responded to the scene. Over the next few hours, the boat suffered additional damage as it was hit by falling debris and ammunition. While the United States would not enter World War I until April 1917, Black Tom was the shipping point for war material being sent to Great Britain and its allies. It was clear that the explosion in Jersey City was just one of several acts of sabotage effected by German agents on the East Coast in response to the British naval blockade of their home ports.

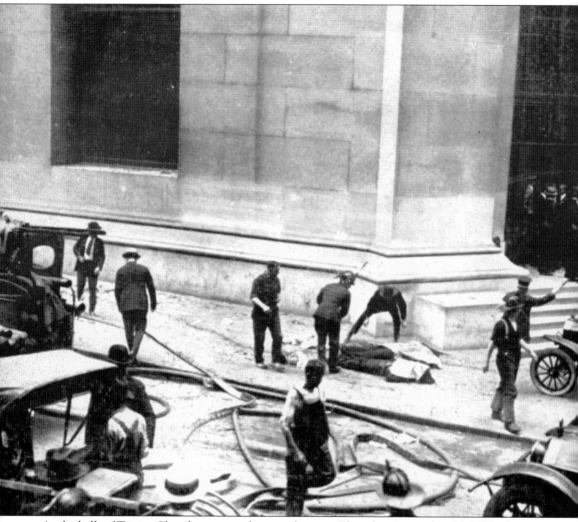

As the bells of Trinity Church rang out the noon hour on Thursday, September 16, 1920, a horse cart packed with TNT and sash weights parked in front of the Morgan Guaranty Trust at the corner of Wall and Broad Streets. It suddenly exploded in a "cloud of yellowish green smoke," shattering windows for blocks around, showering glass into the Stock Exchange, and sending shrapnel whistling through the streets. There was no major fire, but some awnings 12 stories high were ignited. Most FDNY units were assigned recovery tasks. At least 30 dead and 300 injured citizens lay among piles of mutilated bodies and severed limbs. The casualties were clerks, secretaries, and messengers out on their lunch hour. While little evidence remained beyond two horses's hooves, pieces of the wagon, some burlap, wood, and iron, and 10 tons of glass, there is general agreement that anarchists were behind this act of terror. The building façade has never been repaired, and deep scars remain on the walls of the House of Morgan to this day.

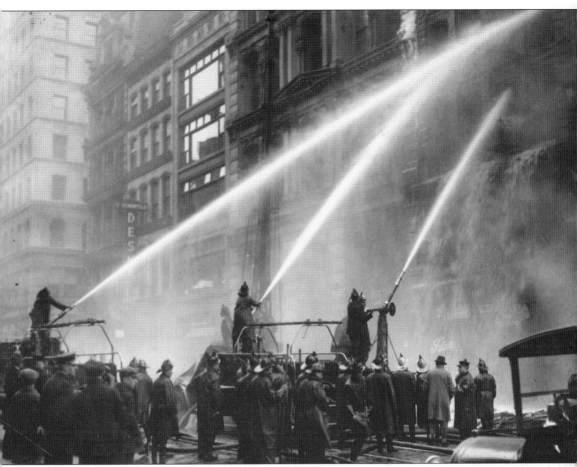

On April 23, 1922, four alarms were transmitted within five minutes following a series of explosions in a five-story loft at the corner of Broadway and Lispenard Streets in lower Manhattan. The building contained a large stock of celluloid being stored by a comb manufacturer. The ingredients of celluloid include both nitric and sulfuric acids. The flames were so intense that buildings across the street were threatened, and spectators a football field away felt uncomfortable.

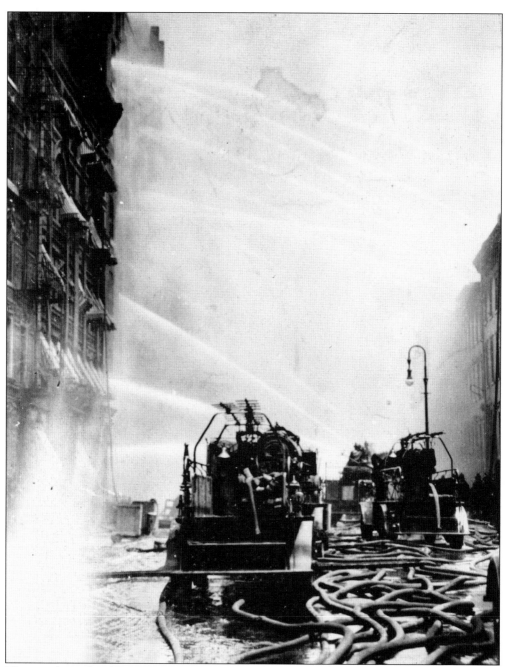

The members of Ladder 5 thought they were responding to a simple rubbish fire on Jane Street in Greenwich Village just after 8:00 on the morning of Sunday, July 18, 1922. They got more than they anticipated. After they directed a stream onto burning cases containing magnesium, a series of explosions in the garage-turned-warehouse killed one fireman at the scene and another who was thrown from his Brooklyn apparatus while responding to the fifth alarm plus borough call in Manhattan. Over the next five days, 200 firemen were overcome, more than 70 civilians were sent to hospitals, and thousands of nearby residents were forced to temporarily evacuate their homes.

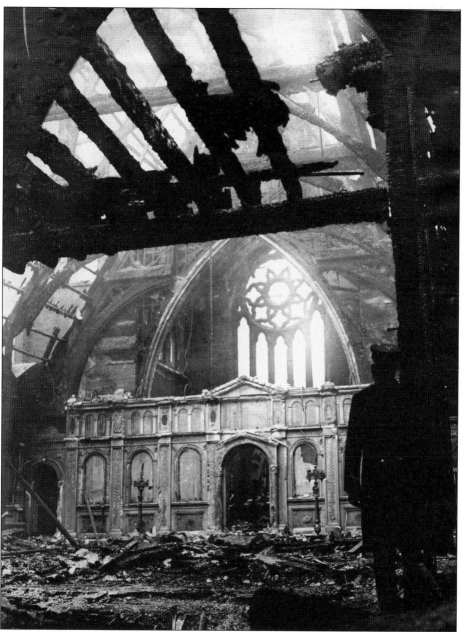

Fire destroyed Holy Trinity Church at the corner of Lenox Avenue at 122nd Street in Harlem on April 16, 1925. Around 7:00 a.m., Engine 90, responding to a report of a smoke odor in the area, transmitted a full first alarm upon arrival. As firemen entered the building, the roof began to groan, and the deputy chief in charge ordered them out forthwith. A few seconds later, the roof collapsed. Flying embers and falling building blocks presented dangers to firemen in what was described as "the most spectacular blaze" experienced in that part of Manhattan in many years. Once Chief John Kenlon arrived on the fourth alarm, he put out a special call to Water Tower 2 up from 33rd Street, and, thus, a small section of the edifice was saved. The fire was under control within three hours, but two companies remained for many hours, washing down the area. The cause of the fire was a short circuit above the ceiling near the roof.

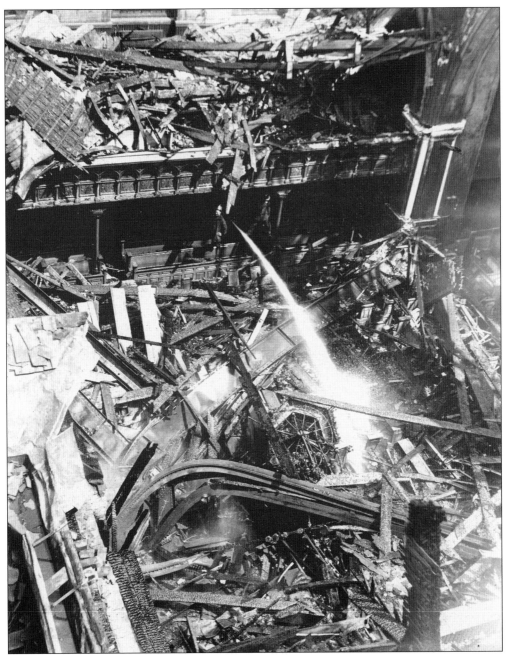

The interior of the church was gutted. A magnificent pipe organ, beautiful stained glass windows, baptismal fonts, and other items were all lost. For a while, Holy Trinity temporarily held services at a Seventh Day Adventist Church at 129th Street and Lenox Avenue, and their former church was never rebuilt. The building was fully insured, but since Harlem was undergoing a period of "white flight," the vestry decided to sell the original site and relocate. Today Holy Trinity's small and struggling congregation is located in the Inwood section of upper Manhattan.

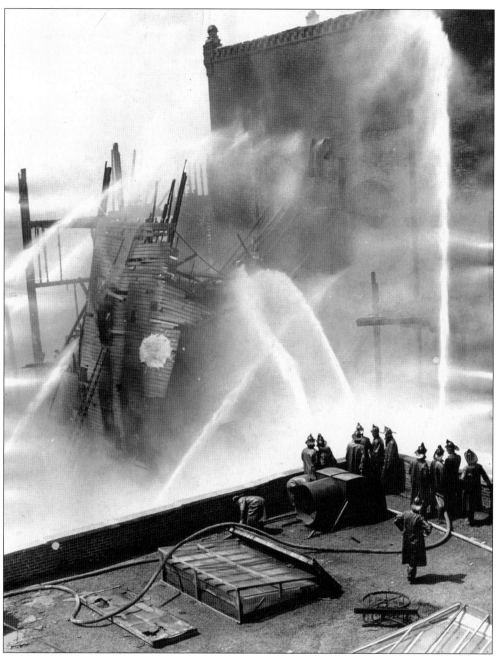

A spectacular fire destroyed an abandoned Brooklyn brewery, a bottling plant, and a storehouse on Grove Street, near Evergreen Avenue, just after lunch on Thursday, June 24, 1925. Five hundred children and teachers who had gathered in an end-of-year general assembly, along with 2,700 of their in-class colleagues, were evacuated from Public School 75 and Franklin K. Lane High School just across the street in under 2.5 minutes. Firemen attacked the fire from the street and from the roof of a former movie theater on nearby Linden Street. One of the interested bystanders was Mayor John F. Hylan, whose home on Bushwick Avenue was just two blocks away.

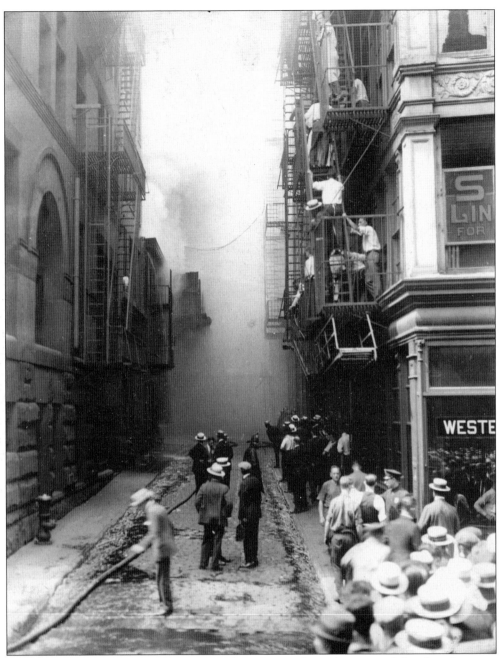

A 100-year-old, 5-story warehouse on Fulton Street, formerly occupied by the pharmacy company of McKesson and Robbins, burned as it was being demolished on August 25, 1925. Toxic chemicals that had soaked deeply into the wood floors were released, and foggy and rainy weather conditions created very dangerous conditions for firemen and onlookers alike. Rescue company members entered the building wearing masks, but they were soon pulled out of the unstable structure by Chief "Smoky Joe" Martin. The second-alarm blaze, which was discovered shortly after noon, was brought under control by 2:30 p.m.

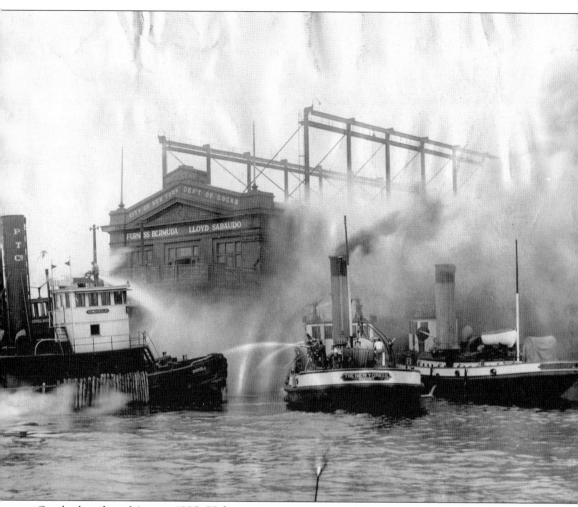

On the last day of August 1925, 75 firemen were overcome, including the entire crew of Engine 65, a deputy chief, and a battalion chief, while fighting a stubborn fire on the Bermuda Line Pier, located on West Fifty-fifth Street and the North (Hudson) River. A third alarm was transmitted as several nearby ocean liners pulled out into the river to avoid being caught in the fire. Four FDNY fireboats attacked the flames under the pier, as firemen on rafts tried to get in close to the blaze. Fireman C. A. Rooney was awarded the Walter Scott Medal for saving the life of a brother firefighter from Ladder 35.

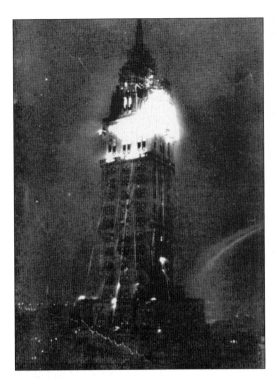

Described as a "gargantuan Roman candle, throwing off a rain of flaming projectiles," fire consumed the 15-story tower of the half-finished Sherry-Netherland Hotel just off Central Park at Fifty-ninth Street on April 12, 1927. After firemen carried rolled-up lengths of hose to the upper floors, they discovered that the building's standpipes were not functioning from the 22nd floor to the roof of the proposed 40-story building.

Chief of Department John Kenlon called two Ahrens-Fox piston engines to pump water to the upper floors, but the volume and flow were insufficient to make any real headway. As blazing timbers fell from as high as the 38th floor, the fire eventually burned itself out as fifth-alarm units patrolled a six to eight block area for brands and wet down the roofs of five buildings.

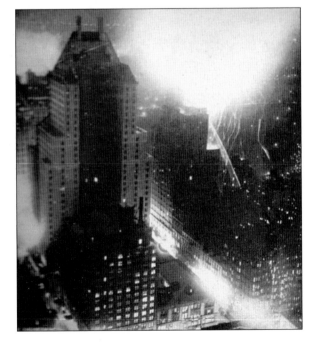

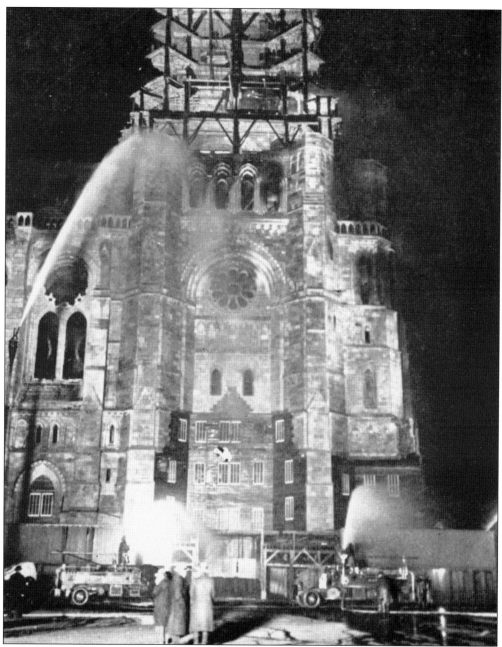

The wood scaffolding of the monumental Riverside Church, under construction at 122nd Street and Riverside Drive, lit up around 7:15 p.m. on December 21, 1928. Heavy winds pushed the blaze throughout the building, creating a serious brand problem as bitterly cold weather turned streams to ice before they hit their targets. While the 360-foot-high spire of the Gothic church survived, along with some masonry and steel framework, the main body of the structure was reduced to a shell within two hours. The reconstruction of the Riverside Church was completed by 1930 and financed by the primary benefactor of the project, John D. Rockefeller Jr.

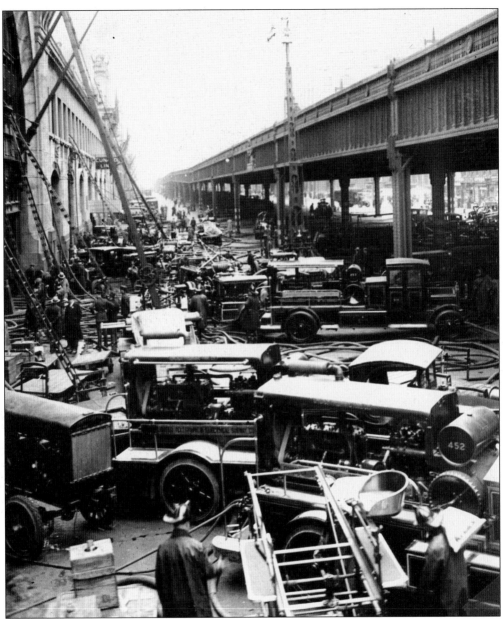

On May 6, 1932, the newly commissioned fireboat the *John J. Harvey*, along with six other FDNY fireboats, responded to its first major fire, an early morning job at the Cunard Pier, at Thirteenth Street and Eleventh Avenue. Four hundred of the 700 firefighters at the scene were treated for injuries and smoke inhalation as yellow smoke from the stubborn fifth-alarm blaze covered the downtown area and drifted over to Jersey City. One civilian, the engineer who had designed the steel work on the "fireproof" structure, was killed when struck by the butt of a breakaway hose. For their bravery in saving a trapped FDNY officer at the Pier 54 fire, Capt. Cornell M. Garety of Rescue 1 received the James Gordon Bennett Medal, and firefighter George E. Cavanagh was awarded the Walter Scott Medal. Lt. George H. Friel of the Cambridge, Massachusetts, Fire Department, and a student at FDNY's Fire College, was also cited for his participation in the rescue.

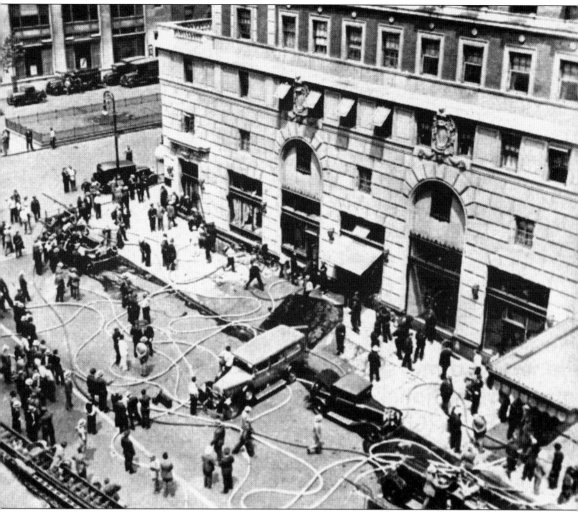

On the first day of August 1932, a fire in a paint storeroom ignited fumes in a second subcellar storeroom of the Ritz Towers Hotel, located at the corner of Park Avenue and East Fifty-seventh Street. The ensuing explosion killed two lieutenants and six firefighters and injured dozens of others. The joint funeral service, the first of its kind in the department's history, was held at St. Patrick's Cathedral on August 4, 1932. The 16 firefighters and officers killed in 1932 were the highest number lost in one year in the history of the paid department to that time.

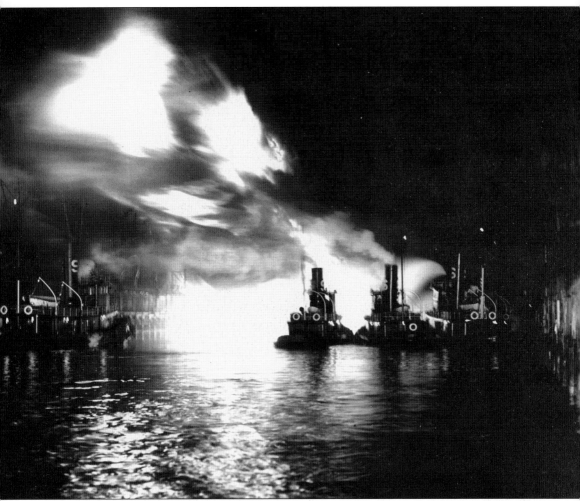

October 13, 1933, was a busy day in the port of Bayonne, New Jersey. At sunset, a fully loaded gasoline barge exploded at the vast Standard Oil Complex located at Constable Hook, a peninsula jutting out into the Hudson at the south end of Jersey City. The FDNY fireboat *Zophar Mills* responded as 40 to 50 explosions rolled out in quick succession, and the blaze extended to adjoining piers. Watchers from the Battery, southern Brooklyn, Coney Island, and the shores of Staten Island saw the *Zophar Mills*, along with railroad and oil company tugs, haul at least a dozen fuel-laden barges away from the flames before the barge finally sank shortly after 9:00 p.m. Less than two hours later, amid the steady howling of his sled dogs running about the deck of his ship the *Jacob Rupert*, explorer Adm. Richard E. Byrd set out from a nearby Bayonne pier, beginning a two-year Antarctic mapping, land-claiming, and scientific expedition.

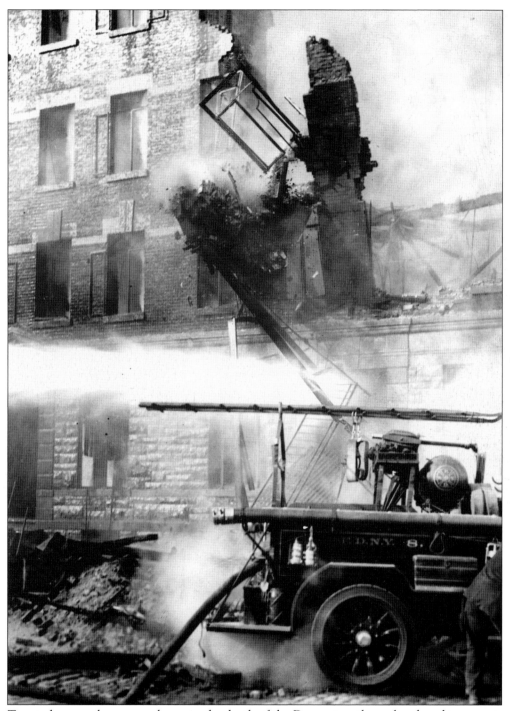

Targeted as an urban renewal area in the depth of the Depression, three abandoned tenements on increasingly upscale Sutton Place lit up in the mid-afternoon of April 4, 1935. Originating in 507 East Fifty-fifth Street, immediately overlooking the East River, the blaze soon extended up the block. One member of Engine 8 who was caught in the collapse of one of the structures was quickly rescued as the fire was brought under control.

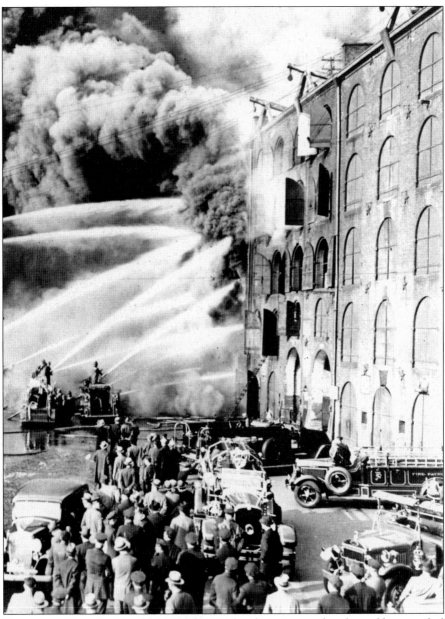

Just after noon on Saturday, April 20, 1935, FDNY faced a serious and prolonged hazmat challenge at the foot of Furman Street, just south of the Brooklyn Bridge. First-due companies were greeted with a heavily banked-down smoke condition, followed by a succession of explosions and backdrafts in Building 38, one of a long row of continuous warehouses holding thousands of tons of rubber, tar paper, and coffee. Seven alarms and numerous special calls for additional manpower brought almost 70 pieces of apparatus and three fireboats to the scene. Toxic fumes were communicated through the subway tunnels through the Clark Street Tunnel to the Wall Street station in Manhattan as more than 1,000 firefighters were overcome. There was a continuous reignition problem since rubber does not absorb water and is very difficult to cool down. More than 300 lengths of hose fused to the pier and were lost over the three-day operation.

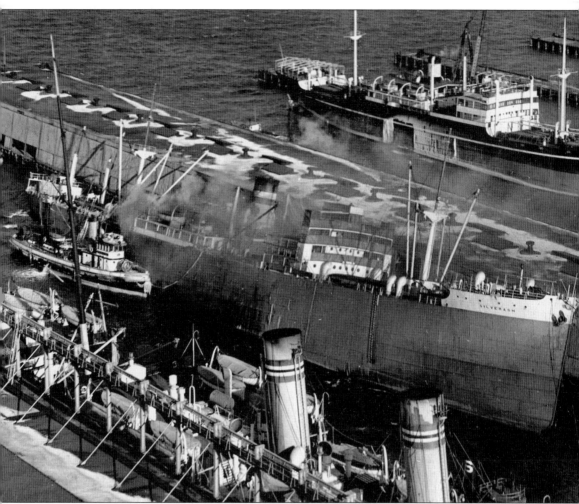

Shortly after midnight, January 23, 1939, fire broke out in the engine room of the British freighter *Silverash*, on its way to Manila. The vessel, docked at the foot of Fifty-seventh Street in Brooklyn, carried baled rubber and 6,000 drums of cyanide and potassium. Chinese crew members and their officers were safely brought ashore. The fireboats *Mayor Gaynor*, *William L. Strong*, and the *Firefighter*, working its first fire, were soon on the scene. Flooded with water, the *Silverash* slowly sank into the mud at the pier. Several firemen were overcome, but they returned to duty that day. In June 1940, a German sub stopped the *Silverash* off the southwest coast of Ireland and sank her with gunfire and a torpedo.

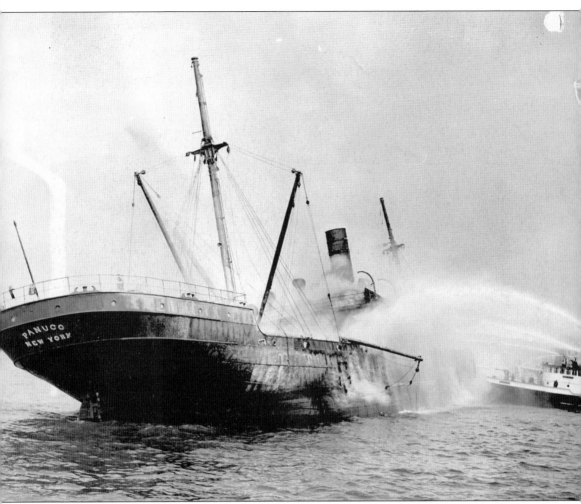

As the first-due battalion commander, Fred Myer, later told it, as he approached Pier 27 at the foot of Baltic Street in Brooklyn at 11:44 on the morning of August 18, 1941, he could see "we were in for something." Both the pier and the SS *Panuco* alongside, crammed with a cargo of oil, paint, paint thinner, bales of cotton, arsenic, quicksilver, and copper, were fully involved. Amid exploding drums, flying like rockets, he transmitted five alarms within nine minutes. With hundreds of workers trapped and many jumping into the water, the fireboat *Firefighter* and the harbor tug *W. F. Dalzell* closed in to pick up survivors braving boiling water near the ship. By the time the *Panuco* was beached on the Gowanus Flats, almost 40 longshoremen and crew members were dead. Members of the *W. F. Dalzell* received commendations. Patsy's Lunch on the pier survived with minor damage.

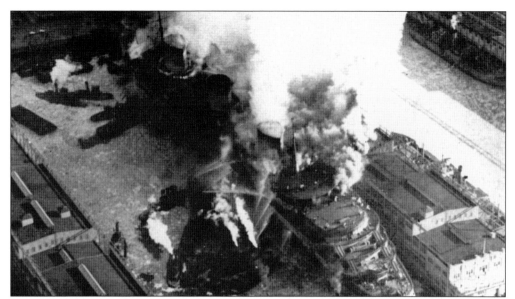

When the Germans overran France in the spring of 1940, the *SS Normandie*, the pride of the French Line, was placed under "protective custody" by the U.S. government and renamed the *Lafayette*. More than three football fields long, and the second largest ship afloat at the time, the "ship of light" was moored at Pier 88 at the foot of West Forty-eighth Street and the Hudson River.

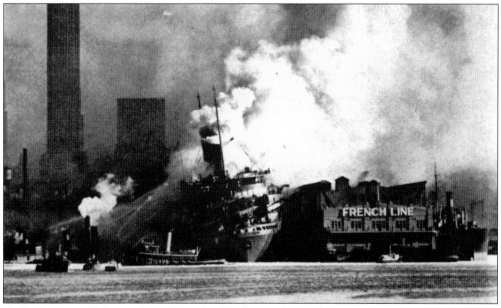

At 2:35 p.m. on February 9, 1942, as the *SS Normandie* was being converted to a troop carrier, sparks from a welder's torch ignited a nearby pile of life preservers. After a 15-minute delay, Box 852 was transmitted at 2:49 p.m., sending four engines, two ladders, one fireboat, and two battalion chiefs to the scene. By the time Engine Company 2 arrived two minutes later, thick plumes of dense, black smoke were pouring out of the ship, and hundreds of workers on board were streaming down the gangways as others were being chased forward to the bow by the flames.

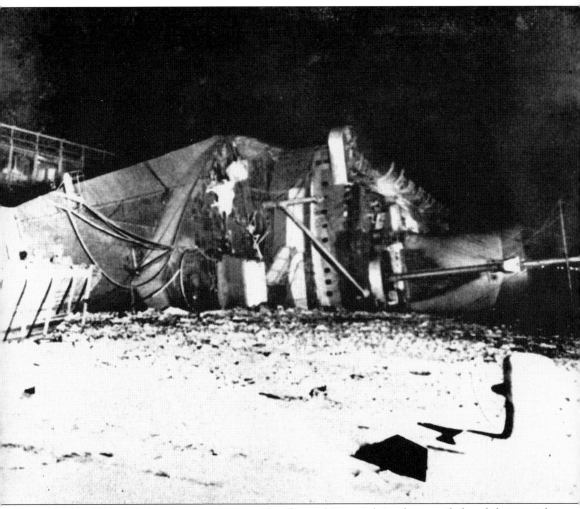

Ladder Company 4 took up a position on the elevated West Side Highway and placed their aerial here, thus enabling more than 150 workmen to escape. Battalion 9 transmitted five alarms in rapid succession. The first water on the fire was delivered by the fireboat *James Duane*, up from her berth at Thirty-fifth Street and the Hudson River. Ultimately more than 40 hand lines went to work, along with streams from three FDNY fireboats and numerous tugs. Around 6:30 p.m., though the *Normandie* was still burning, the fire was placed under control. Operations on board the ship continued through the night, with many hand lines still fighting pockets of fire as the fireboats backed off into the ice-filled river. At 2:45 a.m., the ship keeled over on her side and sank into the mud. One worker died and 288 were injured. Subsequent investigations were unable to determine if the fire was an act of sabotage or not.

Four

1945–2001

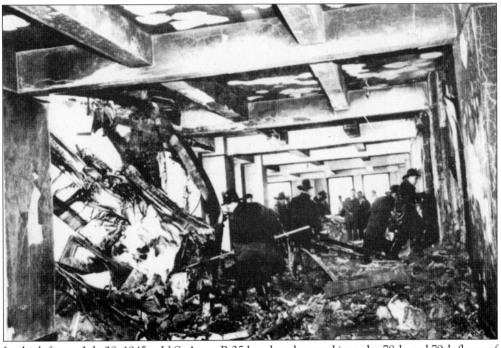

In thick fog on July 28, 1945, a U.S. Army B-25 bomber slammed into the 78th and 79th floors of the Empire State Building. As the building "swayed twice," approximately 900 gallons of aviation fuel ignited, and spread fire laterally. Flaming fuel, motors, and the landing gear also fell down the shafts, cutting the elevator cables as they passed, causing some of the elevators to plunge to the subbasement. According to eyewitnesses, one of the motors of the B-25 bomber dug a two-inch groove in the concrete as it slid and exited out the rear of the 78th floor, eventually landing on the roof of a 13-story loft building on West Thirty-third Street, where it started another fire that went to a fourth alarm. Fourteen people were killed and 26 were injured, most of them workers in the Catholic War Relief Office. The casualties could have been much higher had this crash not occurred on a Saturday morning.

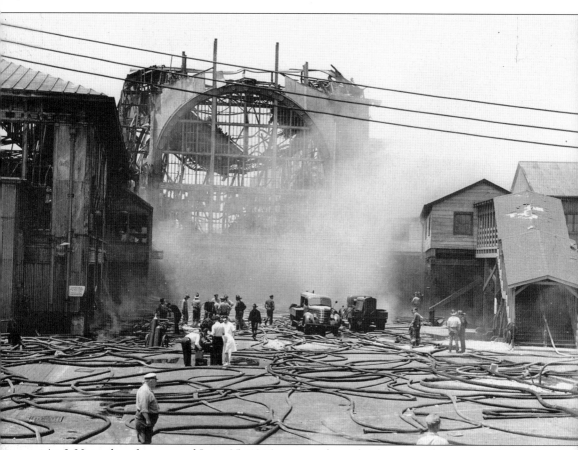

At 2:30 in the afternoon of June 25, 1946, a nine-alarm fire began under a car and spread to a paint shop and the support pilings of the Saint George, Staten Island, ferry terminal. Working quickly, the chief of the Eighth Division transmitted nine alarms, summoning 50 land companies, 6 fireboats, and a rescue company. Well into the struggle, the fireboat *William L. Strong* was almost caught in the partial collapse of the terminal building. The deep-seated blaze was still smoldering more than two days later at what FDNY Honorary Chief of Department Jack Lerch described as "the most stubborn fire" he had witnessed to that time. Three civilians were killed, and more than 250 firemen and 30 civilians were either injured or overcome. The losses could have been even more devastating, for just as the fire was discovered, the ferryboat *Miss New York*, carrying almost 400 passengers over to the Battery, had just departed. The terminal fire was the biggest job faced by FDNY since the *Normandie* burned in 1942.

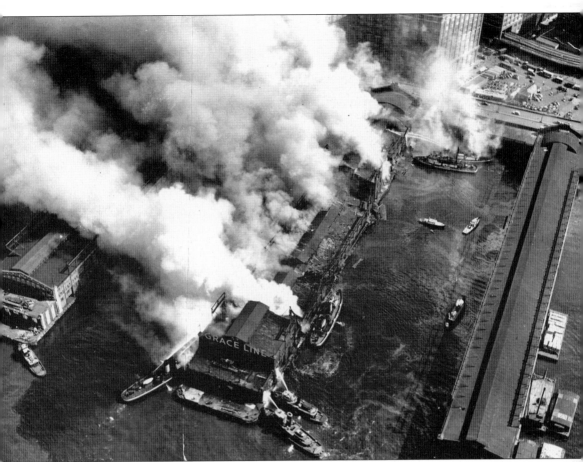

In an eight-alarm blaze, the 800-feet-long, 150-feet-wide Grace Line Pier 57 at Fifteenth Street and the Hudson River was destroyed over a period of six days, beginning on the evening of September 29, 1947. All Manhattan units below Seventy-seventh Street were put to work, along with six fireboats, as a third-alarm assignment came over from Brooklyn. Pneumatic drills were used to crack a layer of concrete on the surface of the pier to provide access to the wooden creosote-soaked understructure. Two hours after the fire was reported, 300 feet of the superstructure crashed, with another 150 feet coming down around 10:30 p.m. The second collapse created a backdraft that sent more than 20 firemen staggering into the street. Personnel were pulled back to safety when the pier's concrete façade on Eleventh Avenue threatened to collapse. More than 150 firemen were treated for smoke inhalation and minor injuries. The liner *Santa Maria*, docked nearby, was towed out to midstream for safety when fire threatened to engulf its home pier.

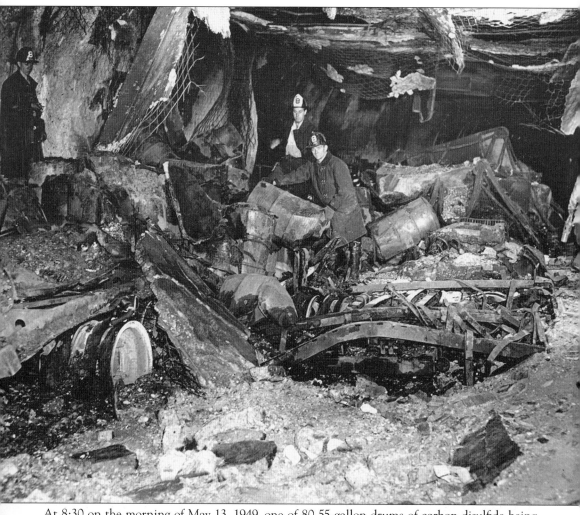

At 8:30 on the morning of May 13, 1949, one of 80 55-gallon drums of carbon disulfide being carried by truck, driving from Jersey City into Manhattan in the Holland Tunnel, broke free, fell to the road, ruptured, and ignited. Dozens of trucks and cars telescoped in the growing haze and began to explode as their drivers ran in terror from the highly toxic fumes.

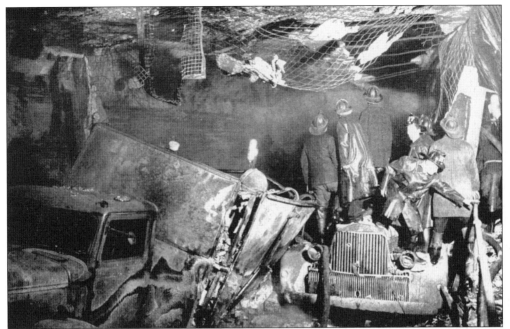

Over the next 45 minutes, Port Authority personnel, the Jersey City Fire Department, and FDNY were summoned to the scene. Superheated temperatures triggered a second fire, west of the original site. Telephone and telegraph circuits were cut, as everything within 600 feet was incinerated in temperatures exceeding 4,000 degrees.

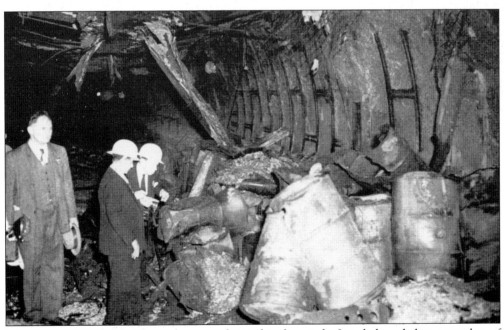

No one was killed, but 27 people were admitted to hospitals. It is believed that a number of deaths among FDNY personnel over the next few years were related to lung damage suffered at the tunnel fire. The Federal Highway Administration identified the Holland Tunnel Fire as one of the world's most serious hazardous material tunnel fires.

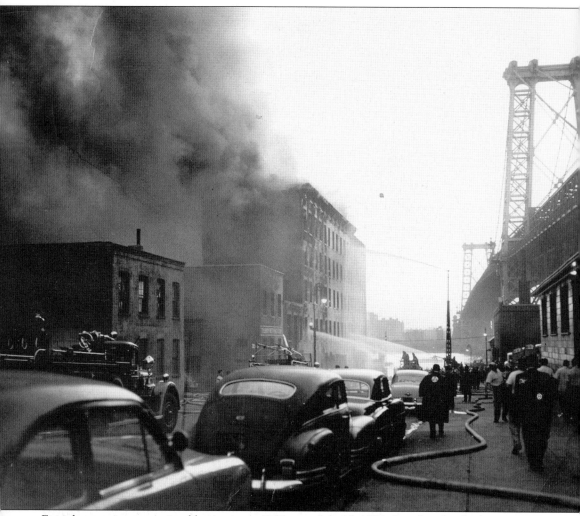

Five alarms were transmitted beginning at 7:25 p.m., July 15, 1954, for a fire that broke out in a five-story, block-long warehouse and factory on Kent Avenue in Brooklyn. Explosions quickly engulfed the building, fed by chemicals from a hat factory, button manufacturer, and a metal plating business. FDNY units from Brooklyn and Manhattan plus 50 Coast Guard reservists in five 40-foot boats worked in dense smoke in the shadow of the Williamsburg Bridge. Smoke was blowing downriver, so traffic on the bridge was not affected.

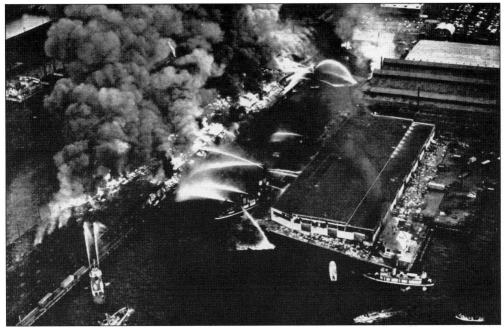

Multiple street boxes were pulled at 3:16 p.m. on December 3, 1956, as fire erupted in the Luckenback Pier at the foot of Thirty-fifth Street in Brooklyn, the longest marine terminal in the city. Sparks from an acetylene torch ignited bags of foam rubber that sprinklers were unable to control. A fifth alarm and a borough call brought six fireboats, rescues, and units from Manhattan to the 1717-foot-long pier, which was crammed with a variety of cargoes, including hundreds of boxes of detonators.

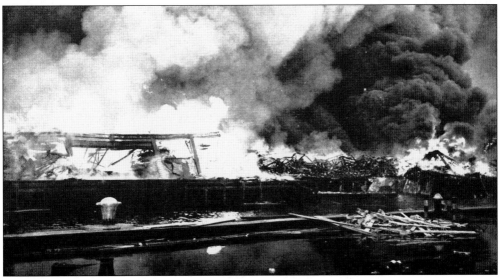

All seven members of the first arriving fireboat, the *Firefighter*, were blown overboard by one of many explosions that showered flaming debris and lit secondary fires all over the area. Fireman Robert F. Christie of Rescue 2 received a medal for saving the life of Lt. Thomas A. Coughlin of Engine 278, who was seriously injured when he was blown into the water. By the time the blaze was declared under control at 6:42 p.m., 10 civilians were dead and over 250 were injured.

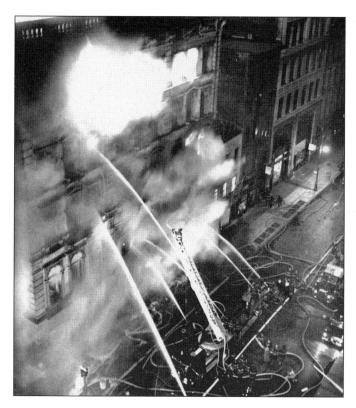

Fire broke out in a building at the corner of Broadway and Grand Streets in the late afternoon of November 18, 1960. With another loft fire in progress nearby, Manhattan units were already spread thin. A total of eight alarms were transmitted, bringing Brooklyn units across the bridge to assist.

A lieutenant and two firefighters were trapped and died on a clogged stairway leading out of the basement of the 100-year-old loft as the blaze extended to five similar structures. The period between November 18 and December 19, 1960, was particularly rough on FDNY, given the Grand Street fire, several other major loft fires, the midair collision of two aircraft over Staten Island, and the carrier *USS Constellation* fire in Brooklyn.

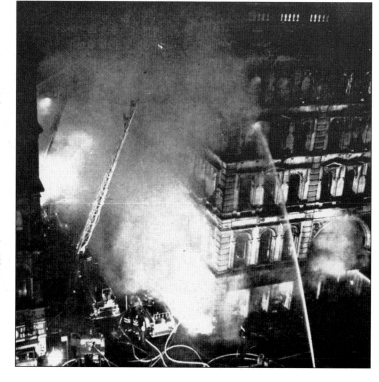

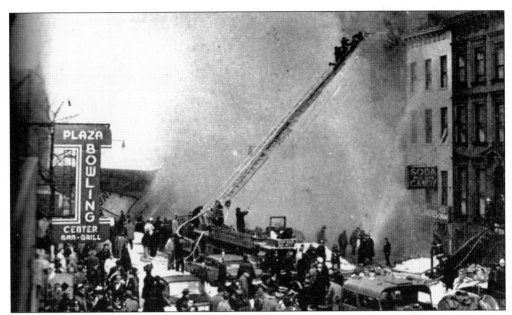

At about 10:21 a.m. on December 16, 1960, a United Airlines DC-8 jet, en route to Idlewild Airport, reported to its corporate air controller that one of its navigation receiver units was inoperative. Their failure to also report the problem to the regional air traffic control center was a fatal error. Out of position and flying too fast, at 10:33 a.m., they collided with a triple-tailed TWA Super Constellation propeller aircraft on approach to LaGuardia.

At this point, the TWA plane broke into three pieces, two of its engines exploded, the wings and the tail section ripped free, and the wreckage began falling onto and around Miller Field (shown here), a virtually abandoned military airport in the New Dorp section of Staten Island. All 44 passengers on board were killed. FDNY units on Staten Island then faced a second alarm.

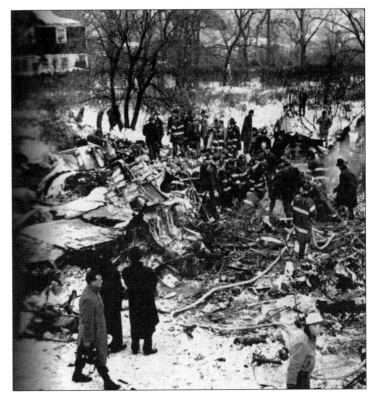

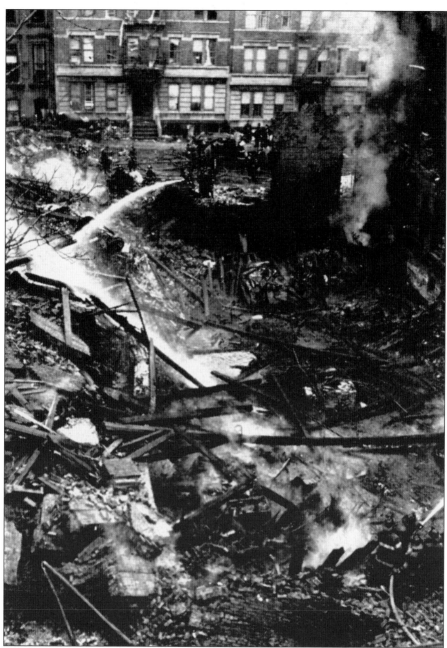

For more than two minutes, the United Air DC-8 continued on, missing its right engine and part of the right wing and losing altitude fast. Suddenly control was completely lost, and the crippled aircraft spun into Brooklyn's Park Slope neighborhood. Banking sharply, it just missed St. Augustine's Academy, packed with school children; its right wing clipped the roof of a brownstone and crashed into the Pillar of Fire Church. The left wing went into an apartment building, as the cabin, full of screaming passengers, demolished McCaddin's Funeral Home. The red, white, and, blue tail fin, with its logo "United" and "Mainliner" prominently displayed, came to rest in the snow-covered intersection of Seventh Avenue and Sterling Place. Five people on the ground were killed, and all but one of the 84 aboard were dead.

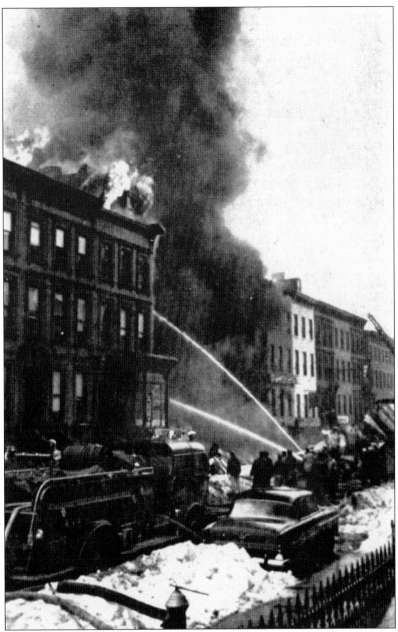

Ladder 105, four of whose members were later cited for heroism, and Engine 269 were the first arriving companies at what turned out to be a seven-alarm fire that drew a second-alarm borough call from Manhattan. More than 50 FDNY companies, including four of the city's five rescues, were summoned to the scene. Members were committed to search and rescue and containment of fire in more than a dozen buildings on Sterling Place and on Seventh Avenue. FDNY Rescue 2 worked continuously for almost 72 hours at the crash scene, primarily in a recovery mode. Just two hours later, the fire was declared under control. The brave struggle for life made by the sole survivor, an 11-year-old boy, was commemorated by a plaque placed in the chapel of the New York Methodist Hospital in Brooklyn. Embedded in the plaque are the four dimes and five nickels that were in the boy's pocket when the plane crashed.

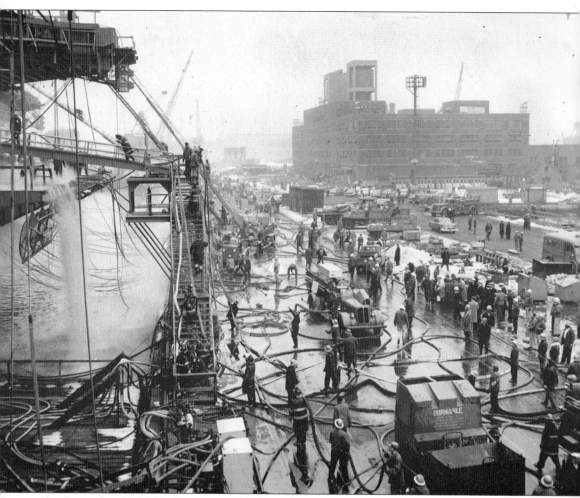

On December 19, 1960, the carrier *USS Constellation* was in the final stages of construction at the Brooklyn Navy Yard when a forklift ruptured a tank containing more than 500 gallons of fuel. Flames quickly spread through the hanger bay, precipitating a huge explosion. More than 4,000 workmen were trapped aboard. Ten alarms were sounded, bringing 600 firefighters to the scene. Companies fought their way to survivors on the lower decks of the superheated interior, as aerials and construction cranes assisted in the evacuation of hundreds of others topside. Fire-suppressing foam was delivered from as far away as Yonkers and eastern Long Island. Fifty workers were killed, and more than 300 workers were injured. Commissioning of the vessel was delayed until October 1961. After 41 years in service, it was mothballed and moored at Bremerton, Washington, in August 2003.

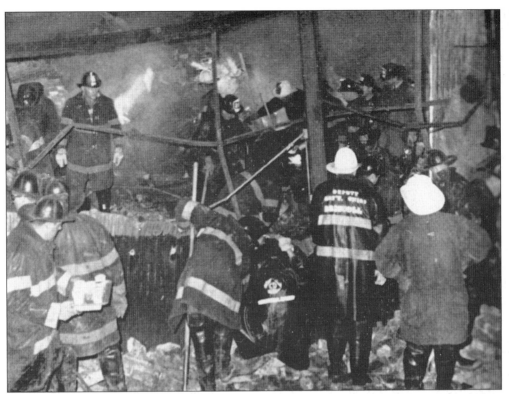

On October 26, ,1962, in a fire at the two-story Sefu Fat and Soap Company, a veteran captain, five firefighters, and a probationary fireman were killed in the collapse of a wall and ceiling just after a fourth-alarm fire had been declared under control. The building was a fat-rendering plant located in the Maspeth section of Queens.

On the day the Flushing Meadow World's Fair first opened its doors, a six-alarm fire closed the Times Square–Grand Central subway shuttle on April 21, 1964, at 4:46 a.m. With flames emanating from the undercarriage of a laid-up train, a nearby wooden platform became involved. Smoke reached the street, rising more than 20 stories. Intense heat buckled steel columns in Grand Central Station, causing the street to buckle near Madison and Vanderbilt Avenues. The cause was an electrical short circuit.

JULY 1966

FIRE ENGINEERING®
R. H. DONNELLEY PUBLICATION

REVIEW ISSUE:
Boston IAFC
Conference

The library of the 12-story Jewish Theological Seminary of America at 122nd Street and Broadway suffered extensive fire, smoke, and water damage on the morning of April 18, 1966. Transmission of the alarm was delayed for 20 minutes while employees attempted to fight the fire on their own. First-due units reported smoke showing from the seventh to the ninth floors upon arrival. Firefighters in the tower faced horrendous conditions, as they advanced a hose line up a narrow iron stairwell into the book stack tower in an effort to limit damage to the collection of hundreds of rare books and fragile manuscripts. At the same time, Ladder 119's 144-foot-long Maxim Magirus high ladder worked from the outside. Companies on lower floors covered materials with tarpaulins to prevent water damage. The cause of the fire remains unknown.

The *Alva Cape* and the *Texaco Massachusetts* collided off Staten Island on June 16, 1966. Liquid naphtha pouring through a gash in the side of the *Alva Cape* washed over an accompanying tugboat, resulting in the explosion that killed most of the tug's crew members. Despite fear of additional explosions, members of the FDNY fireboat *Alfred E. Smith* boarded the *Alva Cape* to search for survivors as police and Coast Guard helicopters hovered above. Here Chief of Department John T. O'Hagan confers with Fire Commissioner Robert O. Lowery, seen standing on the turret of a fireboat.

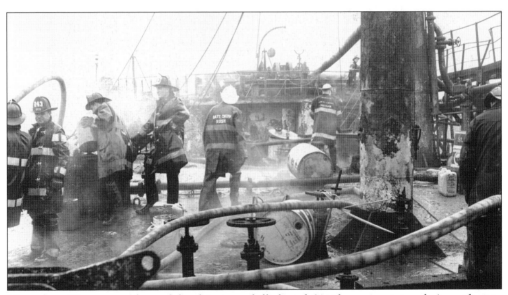

More than 40 crew members of the ships were killed, and 64 others were injured. According to Bayonne's director of public safety, "It looked like D-Day. Dozens of bodies were floating in the water. Flames were shooting up all over the place. The smoke was all over."

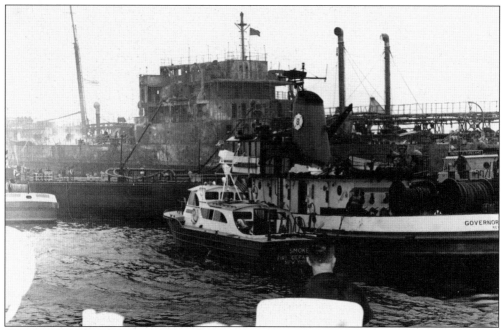

The *Texaco Massachusetts* was towed to a mooring off Bay Ridge in Brooklyn, and the *Alva Cape* was initially pushed aground just west of the Bayonne Bridge. More than 12 days later, four more men were killed and nine injured, including two members of the fireboat *Alfred E. Smith*, in another explosion that occurred as the remaining naphtha was being pumped from the *Alva Cape* at her new mooring about 500 yards south of the Verrazano Narrows Bridge and three-quarters of a mile off the Brooklyn shore. The *Alva Cape* was eventually towed out to sea and sunk.

The superstructure, pipes, and railings of the *Alva Cape* were twisted by the heat. Firemen had to move about the decks with great care to open hatches to vent the remaining naphtha storage tanks.

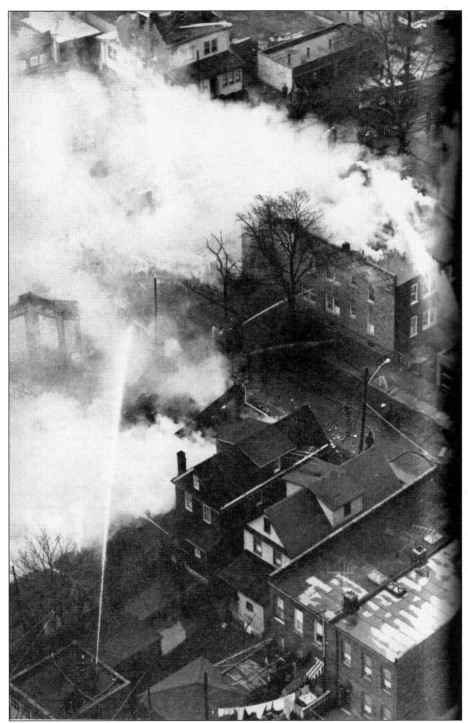

Nine houses were destroyed, and eight were severely damaged, in a gas leak explosion in the South Jamaica section of Queens in the early morning of January 13, 1967. Two companies, Engine 298, and Ladder 127, were initially sent out to investigate a box alarm at the corner of Brisbin Street and 101st Avenue.

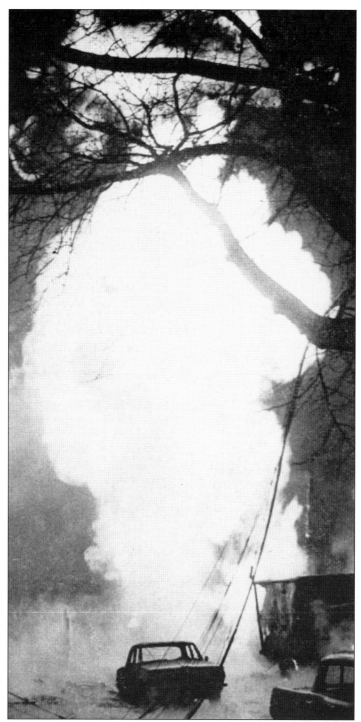

When both rigs stalled as they approached the cloud of gas at the site of the leak, Lt. Thomas Egan realized the seriousness of the situation. Calling for a full first-alarm assignment, he told his troops, "To hell with the engines, let's get the people." And so they did. The massive explosion occurred just minutes later.

Both pieces of apparatus were incinerated. An assistant chief rolling in to the scene saw the flash and sent in the third alarm by radio at 5:36 a.m. Successive alarms were transmitted until a final, 13th alarm was sent in at 6:57 the next morning to bring relief crews to the scene.

The cause of the blast was a loose cap on a major 24-inch gas supply main. According to Fire Commissioner Robert O. Lowery and the commissioner of the Department of Water Supply, Gas, and Electricity, at that time, there were "no specific public service regulations pertaining to inspection, maintenance, or replacement of valves."

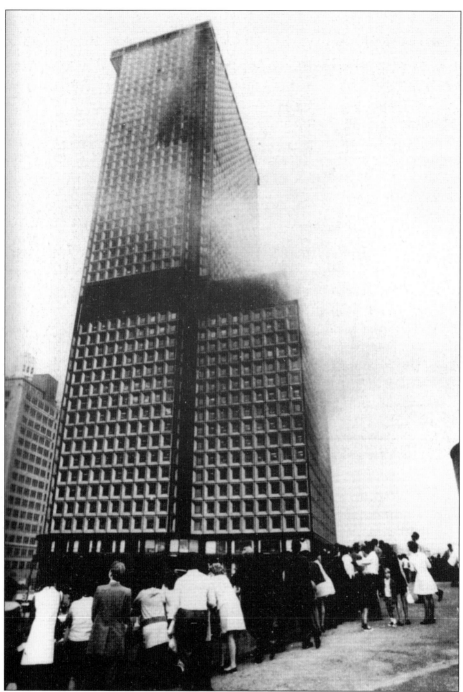

Just before 6:00 p.m. on August 5, 1970, a fire of electrical origin involved the 33rd to the 35th floors of One New York Plaza, a relatively new 50-story office building at South and Broad Streets near the East River, just below the South Street Seaport. In view of more than a 10-minute delay in notifying FDNY, incoming units were presented, in the words of Chief of Department John T. O'Hagan, with "a fire of unbelievable magnitude." The third-alarm blaze, which cost two lives, was brought under control around midnight.

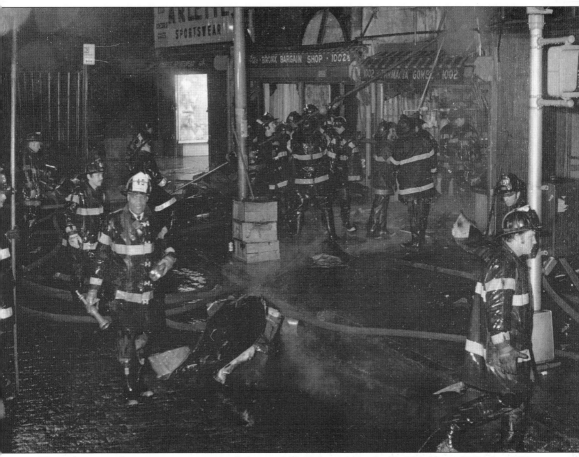

This photograph portrays just one of almost 280,000 runs made by FDNY in 1971. In 1950, the number of alarms in the city had been only 62,021. By 1964, the number was over 128,000. During the "long hot summers" of the 1960s, recalled by FDNY as the "War Years," some fire companies were making 7,000 to 8,000 runs per year, as Dennis Smith points out in *Report From Engine Company 82*. In 1978, Fire Commissioner August A. Beekman put it thus: "New Yorkers finally realized that their city was undergoing a 20th century version of the Burning of Rome. And while Rome at least had a fiddler, the only music to accompany the burning of Brownsville, or the South Bronx, and more recently of Bushwick, were the fire sirens which pierced the air all hours of the day and night. One might well ask, what was the Fire Department doing throughout this period? The answer is that it was trying to hold the line with all the resources at its command." In many ways, events in the 1960s recalled the race- and class-based riots of the mid-19th century.

Just before midnight on February 13, 1975, an 11th-floor cleaning crew in Tower 1 of the World Trade Center reported to the command center in the basement that smoke was emerging from an office on that floor. The command center promptly notified the New York City Fire Department. As windows blew out on the 12th floor, fire spread downward to the 9th and up as high as the 17th floor. Harold Kull, captain of Engine 6, said later, "It was like fighting a blow torch."

A member of the cleaning crew later confessed that he had set at least one fire, and probably more, on the 11th floor. Despite extensive damage to a quarter of the floor of origin, walls and doors prevented the fire from entering the core. More than 20 pieces of equipment, including the Super Pumper System, responded to the third alarm. There were 28 injuries among firefighters. The day after the blaze, Fire Commissioner John T. O'Hagan called for the installation of sprinkler systems in both Towers 1 and 2 of the World Trade complex.

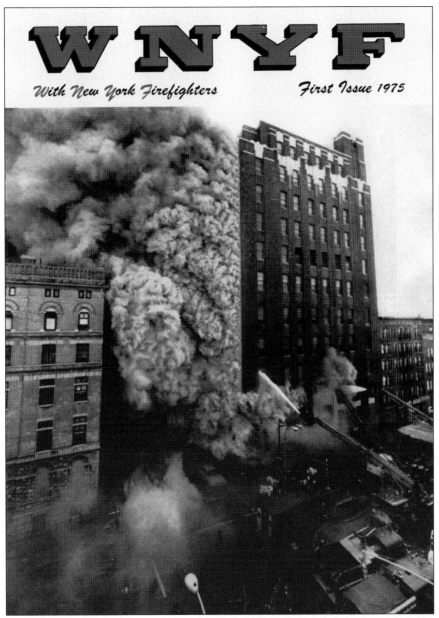

WNYF

With New York Firefighters *First Issue 1975*

A fire of unknown origin broke out in the cable vault below the 11-story New York Telephone Building on the corner of Thirteenth Avenue and Second Street on February 27, 1975. After the fifth-alarm assignment worked for 16 hours, 239 of the 700 firemen were reported injured. In what turned out to be one of the most serious hazardous materials incidents in the department's history, 64 percent of those at the scene reported permanent physical damage. A very high number of those who worked at the fire came down with respiratory illnesses and cancer as a result of inhaling fumes from burning PVC. According to writer John Brooks, "Telephone service was interrupted to over a 100,000 customers, including six hospitals and medical centers, eleven firehouses, three post offices, one police precinct, nine public schools, and three higher education institutions, including New York University." Phone lines were completely restored 22 days later.

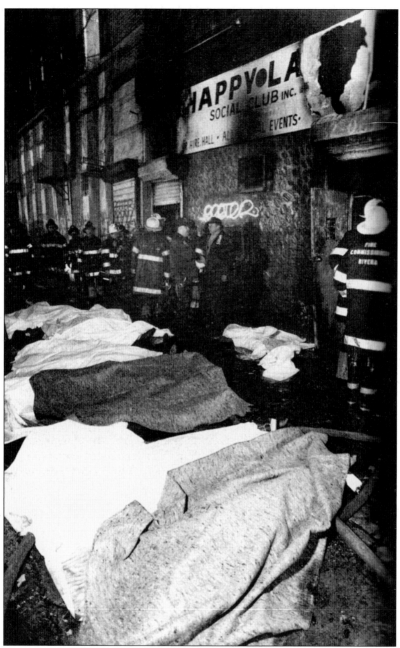

The fire at the unlicensed Happy Land Social Club on March 25, 1990, was the worst mass murder in American history up to that time. Located on Southern Boulevard, just off East Tremont Avenue in the Bronx, the club was a connection to home for newly arrived Hispanic immigrants. That Sunday morning customers were celebrating Punta Carnivale, the Honduran equivalent of Mardi Gras. Following a dispute in the club, a spurned suitor bought a dollar's worth of gasoline, returned, poured it in the hall and stairwell, and lit it up. When FDNY Ladder 58 arrived three minutes after the alarm was transmitted at 3:41 a.m., all seemed quiet in the street. As the companies moved in, they found 87 bodies piled up on the stairwell and the dance floor, all dead from smoke inhalation.

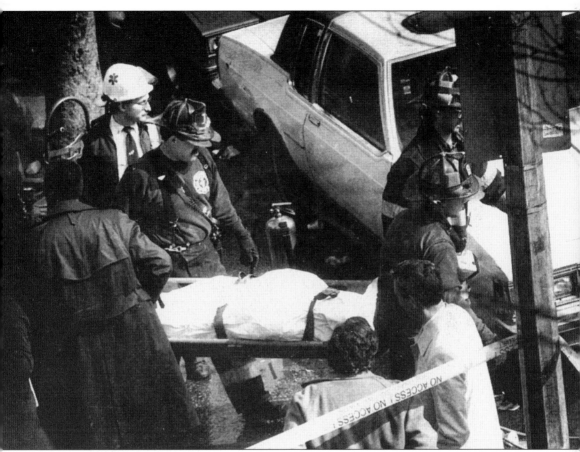

Fatalities at Happy Land were the highest since the Triangle Shirtwaist factory fire, which ironically occurred exactly 79 years earlier on the same day. A suspect was later convicted on 87 counts of murder.

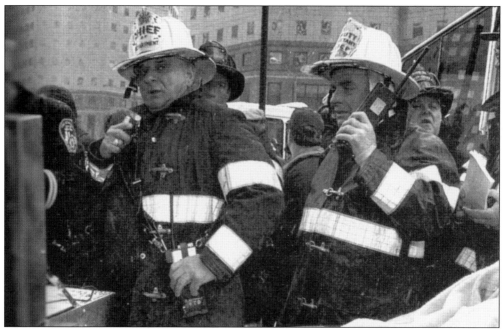

On February 26, 1993, an explosion ripped through the underground garage of the World Trade Center. A 1,000-pound nitrourea bomb was exploded in a rental van by terrorists on the B-2 level, creating a crater 130 feet by 150 feet that spanned seven levels. Six people were killed, and 1,042 people were injured. Here Chief of Department Anthony Fusco (left) directs operations at the largest response of FDNY personnel up until that time.

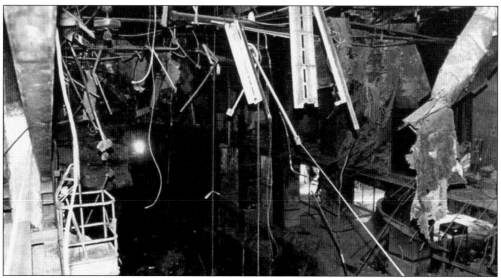

The underground blast area was centered under the northeast corner of the Vista Hotel. Firefighters and other emergency personnel were worried about not only the structural stability of the Twin Towers but the integrity of the slurry wall, which surrounded the complex and held back the tremendous pressure exerted through the soil from the nearby Hudson River. It was estimated that nearly 50,000 people were evacuated from the towers after the explosion occurred at 12:18 p.m.

Walking Tour of

The World Trade Center

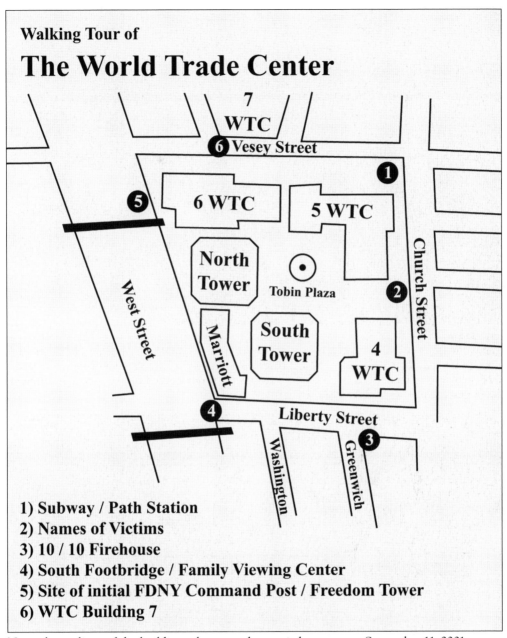

1) Subway / Path Station
2) Names of Victims
3) 10 / 10 Firehouse
4) South Footbridge / Family Viewing Center
5) Site of initial FDNY Command Post / Freedom Tower
6) WTC Building 7

Note: the outlines of the buildings above are shown as they were on September 11, 2001.

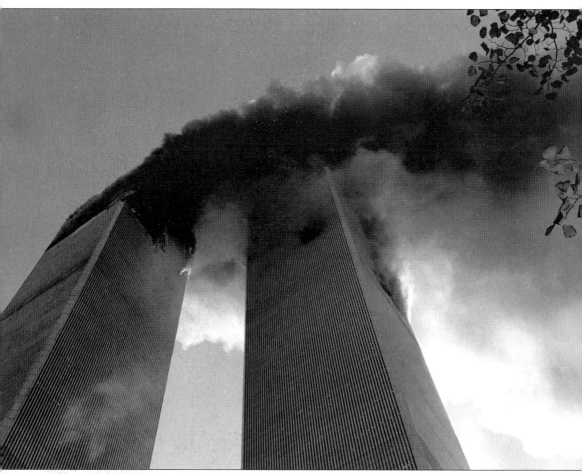

The most devastating attack on American soil occurred on September 11, 2001. At 8:46:30 a.m., five terrorists flew hijacked American Airlines flight 11 into the north face of the North Tower (Tower 1). At 9:02:59, five additional terrorists flew United Airlines flight 175 into the south face of the South Tower. What followed was a disaster of immense proportions. The attacks resulted in the deaths of 2,749 people and left the World Trade Center complex in ruins. The authors provide a Ground Zero walking tour. To begin the tour at Ground Zero, visitors arrive using the subway E train to the World Trade Center stop. Exiting to the south brings visitors toward the PATH station, which is identified as No. 1 on the map. Leaving the subway, note the marble on the floor. This short section of marble walkway is essentially all that is left of the World Trade Center.

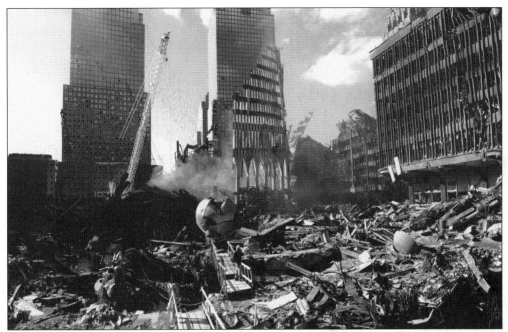

Heading south down Church Street takes visitors to the center of the block (No. 2). Looking toward Ground Zero, the fence in front displays the names of those lost on September 11, 2001. In the image shown, the remains of Tobin Plaza can be seen between the towers. It is marked by a large sphere designed by Fritz Koening. The sphere was removed during the recovery operations and was relocated south to Battery Park.

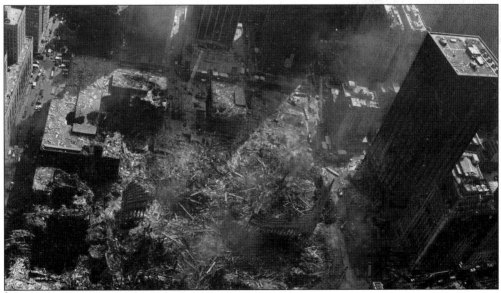

Looking at this image shows the devastation of that tragic day, including the Engine 10/Ladder 10 firehouse at the top of the image. The "10 House" on Liberty Street is identified as No. 3 on the map. Looking through the fence surrounding Ground Zero, the former location of the South Tower (to the left of the covered PATH train tracks) is demarcated by the uniformly spaced column stubs in the soil.

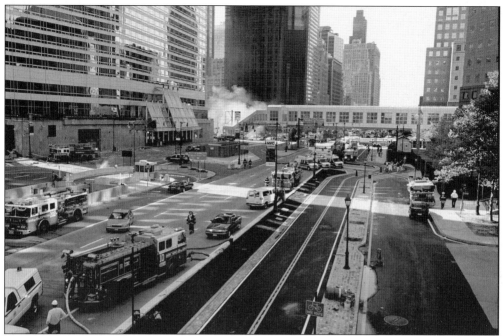

No. 4 on the map is the corner of Liberty and West Streets. As seen early on September 11, 2001, the prefabricated buildings housing the family viewing area, a private area reserved for the victims' families. The future World Trade Center memorial and museum will be built between the 10 House (firehouse) and this intersection, and north to encompass the footprints of the towers. This image looks south toward this intersection (note the footbridge) soon after the North Tower was hit.

Heading north up West Street to No 5 on the map, the location of the FDNY command post, again on the morning of September 11, 2001, can be seen. This image, which was taken from the north footbridge, shows the area above the command post. The new Freedom Tower will rise near this corner. The cornerstone can be seen down below today.

A fireboat pumps water to the disaster scene from the Hudson River, just west of No. 5 on the map. When the South Tower collapsed at 9:58:59 a.m. and the North Tower collapsed at 10:28:22 a.m., the water mains were severed in the streets. Fireboats provided the water necessary to fight the fires raging in the debris.

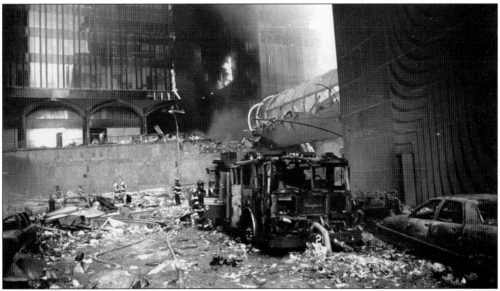

The 47-story World Trade Center Building No. 7 (shown on the right) was hit by debris from the collapsing towers, which started fires and collapsed itself at 5:21 p.m. This photograph shows World Trade Center Building No. 7 facing World Trade Center Building No. 6. The new World Trade Center Building No. 7 with the new extension of Greenwich Street is shown on the map as No. 6. This concludes the walking tour of the World Trade Center site. Please remember the sacrifices made that day.

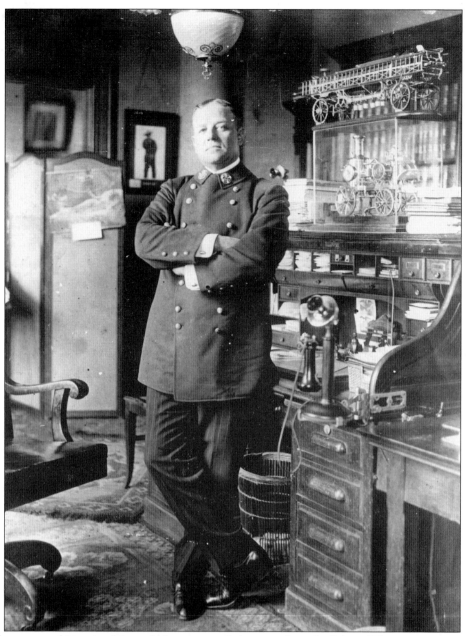

"I have no ambition in this world but one, and that is to be a firefighter. The position may, in the eyes of some, appear to be a lowly one; but we who know the work . . . believe [it] is a noble calling. . . . We strive to preserve from destruction . . . the industry of men, necessary for the comfort of both the rich and the poor. We are defenders . . . of the art which has beautified the world . . . But, above all; our proudest endeavor is to save lives of men, the work of God Himself. . . . the nobility of the occupation thrills and stimulates us to deeds of daring, even at the supreme sacrifice. Such considerations may not strike the average mind, but they . . . fill to the limit our ambition in life and to make us serve the general purpose of human society."

—Edward F. Croker, chief of department, FDNY